Between Two Silences

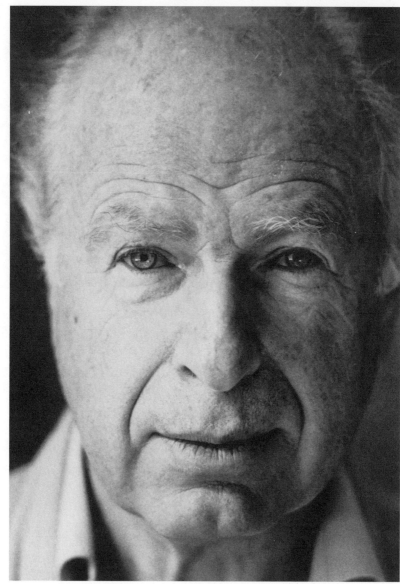

Between Two Silences

Talking with Peter Brook

EDITED BY
DALE MOFFITT

FOREWORD BY
GREGORY BOYD

SOUTHERN METHODIST UNIVERSITY PRESS

Dallas

Requests for permission to reproduce material from this work should be sent to:
Rights and Permissions
Southern Methodist University Press
PO Box 750415
Dallas, Texas 75275-0415

Jacket photograph of Peter Brook by Gilles Abegg
Design by Tom Dawson Graphic Design

Library of Congress Cataloging in Publication Data

Brook, Peter.
 Between two silences : talking with Peter Brook / edited by Dale Moffitt ;
foreword by Gregory Boyd. — 1st ed.
 p. cm.
 Includes index.
 ISBN 0-87074-443-7 (cloth)
 1. Theater—Production and direction. 2. Theater. 3. Acting.
I. Moffitt, Dale. II. Title.
PN2053.B63 1999
792'0233—dc21 99-25841

Printed in the United States of America on acid-free paper
10 9 8 7 6 5 4 3 2 1

For Claire

... there are two ends of the pole of silence. There is a dead silence, the silence of the dead, which doesn't help any of us, and ... there is the other silence, which is the supreme moment of communication—the moment when people normally divided from one another by every sort of natural human barrier suddenly find themselves truly together. ...

In between the two silences ... are the ... areas where all the questions arise.

PETER BROOK

Contents

Foreword

Peter Brook's journey through the contemporary theatre has been a marvel of reinvention. As an interpreter of Shakespeare, of opera, of Broadway musical comedy, of the avant-garde and currently (one will never say "finally" when speaking of Brook) as the leader of the Paris-based center for theatre research that has delved into diverse cultures and myths modern and ancient, he continues to question the relationships between theatre and society. And he has been the inspiration to two new generations of theatre artists as the model for what a director might be.

Indeed, what other theatre director could imagine (as Brook has) an epic production *based* on the history of stage direction from Saxe-Meiningen through Meyerhold and Stanislavsky, and on to Brecht, Artaud and Grotowski? The craft of direct-

ing for the theatre, only one hundred years old, has already seen in Brook not only one of its chief definers, but certainly its chief redefiner as well.

Early on in his long career, Brook not only staged his productions, but designed the scenery and costumes, composed the music, and conjured up the most striking effects with the aim of achieving the Wagnerian ideal of "total theatre." All the different elements of theatre could come together, under the gaze of director as super-boss, into a synthesis that would create something quite a bit more than the sum of the parts. From this—practically a definition of the word *auteur*—Brook has moved to the notion of an actor-centered theatre. The actor as human being—standing before other watching human beings—is the real embodiment of "total theatre": all possibilities exist and are present within him and alive at any moment.

This simplicity of the actor and spectator in the empty space, far from being a "minimalist" theatre, is for Brook (and for

Mel Gussow, who coined the word when writing about Brook's troupe at LaMama in 1980), "maximal" theatre. The audience and the performer can recognize that they are all part of the same family. The audience are allowed to realize that the actors are not different, not more mysterious, not superior. The actor's task then, is to lead the audience into unknown territory—so the actor has to create the confidence that will encourage them to go along, keeping close to them, and heading towards an exploration of something that neither actor nor audience have yet discovered.

"One must hold strong convictions—and then let go of them," says Brook. His early embracing of the idea of the super-director and his firm adherence to the picture-frame stage have all been changed through working. These early strongly held convictions were discarded and something else tried until gradually, through long work, he has come to a point almost directly opposite from those early beliefs. This is the great theme of his work, of his own writings, and

it runs clearly through these pages. It is the book's greatest lesson and greatest inspiration—the willingness to entertain a constant reimagining of what the theatre is and what it can be. And it is what is most exhilarating about listening to him. Brook doesn't embrace anything approaching a "technique" (a cold-blooded word) but rather asks the actor to replace an adherence to technique with a quest for sensitivity—to exercise every part of the body, mind, observation, and feeling, so to be alive and available to every moment of improvisation, rehearsal, and performance.

"When we use words we're always doing a disservice to ourselves." Brook concludes, in his recent book of recollections, that he is unable to articulate what it is that has inspired him over his career. "Not knowing is not resignation," he writes, "it is an opening to amazement." This book of Brook in dialogue is an opening to amazement for all of us who work in the theatre, or teach it, or think about it. True, we get insights about the past masterpieces he has created, but it is his enthu-

siasm for new ways to approach the work, free from any individual set of rules or philosophy, that makes this perhaps the most *useful* of the Brook books—and certainly the essential companion to his own ruminative voice in his previous four volumes. It is certainly the best book about directing I have encountered, save Brook's own.

GREGORY BOYD
Houston
April 1999

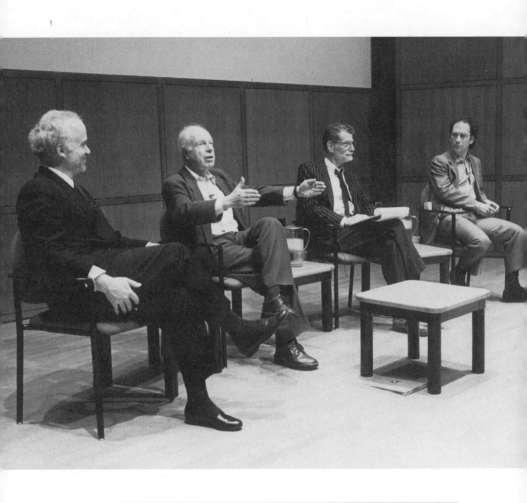

Gregory Boyd; Peter Brook; Dale Moffitt; and Richard Hamburger,
Artistic Director, Dallas Theater Center

Photo by: Andrew Hanson

Introduction

I first was made seriously aware of Peter Brook through the efforts of a close friend. She had seen Brook's New York production of *Marat/Sade* while still in high school, and had felt herself part of a very special theatrical event. Then sixteen, she wrote Brook to share her feelings with him. He replied to her letter. She was to become the most loyal Peter Brook fan I have ever encountered.

An artist herself (a photographer), she found personal validation in Brook's bravery and unconventionality. The boldness of his theatrical explorations encouraged her to explore, to risk, and to depart from artistic conventions in her own work. Influenced by a man whom she knew only through the plays and the films he produced, she was one of the "people sitting in darkness," of whom Brook speaks.

Several years ago, she became ill. So that she might see the Théâtre des Bouffes du Nord, the renovated vaudeville house that serves as Brook's Paris base of operations, I arranged a trip to Paris for the two of us. She, in turn, enlisted a member of the American Embassy staff as a liaison with Brook's office. On the fourth day of a seven-day stay, we returned to our hotel late in the evening to find that Brook had called. They met the following night, after she had attended a performance at the Bouffes du Nord. The meeting lasted until almost one A.M.

She faced her illness with a new strength and, in fact, experienced a personal renewal that was in no small measure related to the Paris meeting.

Four years later, it was announced that Brook had accepted the Algur H. Meadows Award for Excellence in the Arts, presented by Southern Methodist University in recognition of international achievement in the creative and performing arts, and would visit Dallas briefly to receive the award.

My friend's illness had progressed. She was now not able to fly to Dallas for Brook's visit, as we originally planned, but during the visit, as Brook and I waited to begin a panel discussion, he asked me for her address.

Subsequently, her illness moved into its final phase. Our last conversation, however, was not about the invasion of the cancer; it was about the copy of *The Open Door* Brook had just sent her, and about the note which had accompanied it. She died not long after his Dallas visit. She was forty-eight; her life had been touched by Brook for over thirty years.

We speak of theatre as having the potential not only to reflect but also to change. Brook's work and, as importantly, his personal example have the potential to change lives; I have experienced that potential directly.

Although my own immediate experience of Brook began with the national tour of *The Visit* in the late 1950s, it was

A Midsummer Night's Dream, performed at the Aldwych Theatre, London, in 1974 that began my real relationship with his work. It was one of the most thrilling evenings of theatre I had ever experienced. In 1987, I attended one of the nine-hour marathon performances of the magnificent *The Mahabharata,* at the Brooklyn Academy of Music's Majestic Theatre, and a year later I saw his production of *The Cherry Orchard,* also at the Majestic. (This theatre, created as a setting to house the New York presentation of *The Mahabharata,* is a spiritual replica of the Bouffes du Nord, and was designed specifically to be so.) In March 1989, my friend and I visited the Bouffes du Nord, and a few hours later sat down to the meeting with Brook. In 1993, as a member of the SMU theatre faculty, I was appointed to the steering committee in charge of preparations for his visit to Dallas.

The unique range of Brook's talents in both film and theatre encouraged us to devise sessions for his visit which would explore each discipline. Topics ranged from acting and

directing to design to dramaturgy and beyond. To heighten the sense of occasion, Brook's residency was augmented with visits by Glenda Jackson, actress and member of Parliament; Irene Worth, actress and author; Gordon Davidson, Artistic Director of the Los Angeles Center Theatre Group; Gerald Feil, cinematographer; and Marie-Hélène Estienne, Brook's production assistant.

Because our students would not be able to experience his theatre work directly, we screened *The Empty Space* and the film version of *Marat/Sade* in advance of Brook's visit. To represent his work in film, *Lord of the Flies* was to be shown during the visit itself.

Brook flew into Dallas from a Houston conference at which Oliver Sacks was a participant. (Brook's company was then at work on *L'Homme Qui* [*The Man Who*], an adaptation of Sacks's neurological case histories, *The Man Who Mistook His Wife for a Hat*.) He was courteous upon arrival, although he seemed

very tired. His most striking physical feature is his extraordinarily pale blue eyes. In conversation, he listens the way a very good actor listens. An actress friend of mine once described a state of grace as "two people actually present to each other." Brook listens in a way that makes you feel he truly is present to what you are saying. In a unique way, he reassures you that you really do exist.

Once Brook was in contact with his Dallas audiences, he relaxed visibly. As he relaxed he became more accessible. He participated in six seminar, class, and discussion sessions—a total of approximately fourteen hours—plus a black tie award ceremony featuring tributes from the distinguished guests, a luncheon with students, and a final farewell luncheon hosted by the sponsoring Meadows Foundation—all in two and one-half days.

Brook's visit repeatedly underscored the chasm between experiencing theatre and *talking about* the experience of the-

atre. He was hesitant always to speak about things which by their nature were meant to be experienced directly, yet he was gracious in honoring the desire and need of his audiences to intellectualize experiences not available to them at first hand. Too, he repeatedly expressed a reticence to dwell on the past, clearly preferring to look at the present and the future of his work. Nonetheless, he was generous in receiving and answering questions about projects and attitudes which were now over for him.

Brook's professional reputation preceded him. He is known to be demanding; he is reputed to be at times inflexible and even difficult. What I had not been prepared for was the depth of his personal grace. It is a truism of acting, and actor training, that an actor empowers his or her partner, i.e., if an actor says yes to the work of a partner, it becomes impossible for the partner to make a mistake. Brook empowered us in this way. If we had prepared a seminar subject clumsily, in his addressing it, the subject became an acceptable formulation. If an audience

member offered a halting and uncertain question, by the time Brook had answered it the question had acquired wisdom and substance. (Theatre scholar Albert Bermel, reviewing this book in manuscript form, suggested that "Brook doesn't literally *answer* each question," but rather "corrects or rephrases the question, then replies to his version of it.")

Brook's affinity and preference for open question and answer sessions quickly became clear. Nothing seemed to please him more than exploring give and take with students. For example, as the audience asked him about meanings in *Lord of the Flies,* motives in its making, etc., he began to question audience members about their perceptions of the film and their responses to it. In a short time, he had achieved a new format in which audience members were debating responses to the film among themselves, while he listened and guided the discussion.

Of the six sessions in which he participated, he refused only once to allow recording. His master class with graduate and

undergraduate actors, working with prepared Shakespeare pieces, was off limits to cameras and tape recorders. This was, as far as I know, the only time he said no during the entire visit, and the refusal was consistent with his belief that an actor's work is to be prepared privately, and is adversely affected by observers who are not a part of the preparation process. It was also the only session in which I felt him to be less than comfortable. The session was inconsistent with the reality of his work with actors, and the request had been inappropriate on our part. His usual courtesy prevailed, however.

On only one occasion during the visit did he show slight annoyance—during a discussion of "manipulating" the perception of art. That response is included in the material which follows.

At the end of the Dallas visit, at his request, we scheduled an outdoor box lunch with students, an event at which faculty and

administration were clearly intended to remain in the background—that he might move freely among the students, addressing their concerns and interests without stricture or guidance from a steering committee. He mingled with the theatre students informally on the steps of an outdoor fountain, moving from group to group with box lunch in hand, effortlessly, comfortably, with warmth and humor. The students found him accessible and receptive to their concerns and interests.

The verbatim transcript of the five recorded sessions is 218 pages, edited to just under 90 pages for use here. In these pages, I have attempted to reflect Brook's artistic vision as it was expressed in these public sessions.

The arc of Brook's career is present in his replies to the questions he confronts—from his initial and ongoing fascination with film which, when his screenplays were not embraced by filmmakers, led to an exploration of theatre, to the theatre's

more welcoming responses which set him on a theatrical track leading also to opera and back to film.

Theatre has occupied most of his time and energy. Brook notes his initial equation of theatrical simplicity with theatrical mediocrity and his resulting preoccupation with manipulating theatrical elements—light, color, movement—to heighten audience involvement. From this grew an awareness that theatre was not, in his words, "a static image," but "a rhythmic structure," a realization which in turn shifted his focus to "the human being, and nothing else."

His later search for "variety" in his audiences moved Brook away from the more sophisticated theatregoers of continental theatre and toward a theatrical simplicity which would hopefully engage a new range of audiences. The search required exploration of venues outside the limits of conventional theatres and resulted in the move away from his successes at the Royal Shakespeare Company, his relocation to Paris, the

establishment in 1970 of the Centre International de Créations Théâtrales, and has led to his period of greatest influence on contemporary theatre. He does not today deny any element of theatre; it is rather that for him "the starting point has been reversed," i.e., from design to human being.

In the course of his search, Brook encountered other innovators, among them Antonin Artaud and Jerzy Grotowski—the former "as a stimulus, not as a recipe," the latter as a strong collaborative influence.

His move to Paris and the subsequent creation of an international company have fostered exploration of the multiculturalism which so uniquely and importantly characterizes his recent work.

Each step has moved Brook forward in his search to know "the heart of the theatre experience," that experience which enables an audience "to enter into a living situation truly in a

different ... and a more intense way, than if one encountered the same situation in any other part of one's ordinary day."

Although campus visits by distinguished guests are momentarily exciting, more often than not they are of such short duration that real or lasting benefit is problematic. The opportunity to listen to Brook, to share his interaction with audiences, to watch his effect upon our students, all had been remarkable gifts. Once past the event, however, it became increasingly difficult to hold on to its substance, as well as the immediacy and excitement which had characterized it.

I have prepared this text for two reasons. In part, it has been for my friend; in part, it has been to insure that these discussions remain alive to those who were present for them, and, perhaps more importantly, are made available to those not fortunate enough to have experienced them at first hand.

Perhaps these aims go against Brook's unwillingness to hold on to events once they are past. Notwithstanding, I have needed to make the attempt.

I was concerned initially that the text might be simply a duplication of Brook's own previous writing. (*The Open Door* had been published only a few months before these sessions took place.) This concern led me to a comparison with Brook's already published work and other related material. In that review I found further validation of the text which follows, and in editing the question and answer sessions against Brook's existing books—*The Empty Space* (1968), *The Shifting Point* (1987), *The Open Door* (1993), and, more recently, *Threads of Time* (1998)—I grew to admire Brook even more. There is relatively little duplication between Brook's own written material and the Dallas sessions. Ideas, phrases, terms contained in his own writing or occasionally in published interviews do reappear here. Yet, consistently, they appear *differently*.

Brook is not a "tape loop" thinker. As he appears not to take anything for granted, he does not take even his own thinking for granted. Rather, he is "in the moment" of his thinking as he expects theatre to be in the moment of *its* existence.

The context also directly influenced the content of the sessions. The books are personal, private, and essentially internal. In the question and answer sessions, Brook felt responsibility to a specific, *present,* audience. True to his expressed opinion that an actor cannot play what he or she has played previously because the audience and its moment have changed and are now different, Brook in the Dallas meetings continually recrafted his thinking, and hence his answers, to the reality of the moment in which those questions and answers were being shaped.

The dialogue which follows contains echoes of the four books. Consistently, however, the spoken answers provide new or expanded perspectives. In the Dallas sessions, Brook would

mention a term or an event, but not develop it. I would find the development in one of the books (e.g., the extraordinary discussion of the African travels found in *The Shifting Point*; the expanded consideration of "pulse," "tempo," and "rhythm" in *Threads of Time*). In turn, in the books, Brook would mention a term or an event, but not develop it, and I would find the development in the answer to a question from one of the Dallas sessions (e.g., the discussion of specifics in Grotowski's work; the comparisons of Brook's and Grotowski's aims). I have chosen to retain some apparent duplications (playing in schools during rehearsal periods; the discussion of *Love's Labour's Lost,* at Stratford) because when seen in perspective the repetition actually amplifies the topic (the element of design in *The Tempest,* as it was affected by the school visit; the Stratford comments by Michel Saint-Denis). Overall, I found that if one source contains the near side of a point, the other source may develop its far side; the points are clearly related, yet in sum they are different.

A few anecdotal duplications have been removed.

In editing the original transcript, I have been guided in all cases by the sound of Brook's voice. I refer not to mystical auras, but to the repetitions of twelve hours of Brook on tape, as well as fourteen hours of being present to hear his actual answers, as well as personal contact with him. I was guided by hearing Brook's voice in the words on the page—his unique cadences, his verbal style, his sentence structure, the way he tends to shape a thought. When that voice seemed to be lost, I went back to the tapes to find it, and reworked the edited text until it reappeared. I note that because I had been "hearing" him on the page for so long (it took two years to achieve the final transcription, and another six months before the first rough edit was complete), I unexpectedly carried this habit into the review of his books. I hear his voice most vibrantly in *The Shifting Point,* less evocatively in *The Empty Space* (almost thirty years old, and still a major theoretical influence) and

The Open Door. For this reason, *The Shifting Point* engages me the most. Its vivid, interactive quality characterizes his time with us. The other books are more self-contained, focusing more on answers and less on an interaction of the answer with the question. *Threads of Time,* autobiographical in content and more personal in focus, exists largely apart from the earlier works and is the least directly related to the Dallas visit.

Brook's visit was rich and full. Our students responded to him forthrightly, without undue awe, but with a hunger for his knowledge that was unabashed in its eagerness while carefully contained within their own standards of courtesy. Brook gave of himself unstintingly; he also received that vitality of youthful inquiry to which he seemed so drawn.

Discussing *L'Homme Qui,* Brook has described his aim as being "to touch spectators with direct, unfiltered experiences and

let them ask their own questions." For two and one-half days in Dallas, he did just that.

DALE MOFFITT

Dallas

April 1999

Between Two Silences

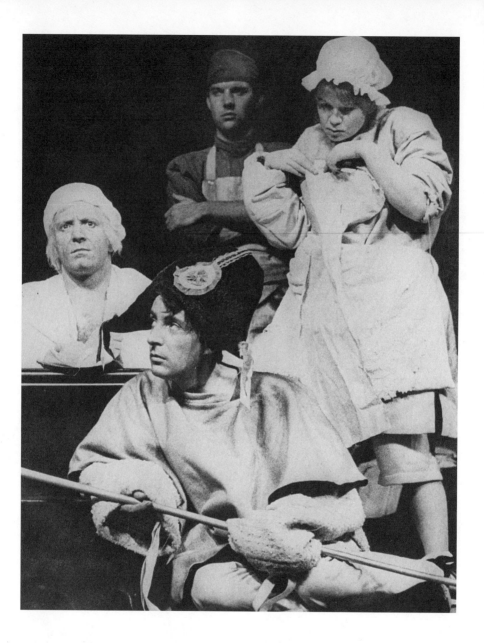

I.

Elements of a Theatre Aesthetic

Marat / Sade (1965)

"One of the things that was, I think, central in the experience of working
on the *Marat / Sade* was to see that there is nothing romantic about being
mentally sick. The idea that this is a form of genius, and it liberates
great areas of inner freedom, is just not true. On the other hand, mentally
sick people can have momentary and quite extraordinary insights, but
basically they live through endlessly tragic experiences." (p. 31)

Photo courtesy of: Shakespeare Centre Library, Stratford-upon-Avon

A*lthough subsequent material has been reordered by topic, this was Brook's opening statement, his answer to the first question at the first public session of his visit. The atmosphere at the beginning of the session was both charged and expectant. The space, a steeply raked lecture hall seating approximately 160, was filled with theatre students, both undergraduate and graduate, faculty, and members of the general public. Invited guests present included Glenda Jackson, Gerald Feil, and Gordon Davidson. After brief statements of welcome, the moderator asked the first question.*

Question: You have defined the act of theatre as a man walking across an empty space while someone else is watching. I wonder if you would discuss some of your own encounters with artists and with audiences.

PB: [A long pause.] You see, this is exactly how it starts. With a silence. There are two silences. Perhaps there are many, but there are two ends of the pole of silence. There is a dead silence, the silence of the dead, which doesn't help any of us, and then there is the other silence, which is the supreme moment of communication—the moment when people normally divided from one another by every sort of natural human barrier suddenly find themselves truly together, and that supreme moment expresses itself in something which is undeniably shared, as one can feel at this very moment. In between the two silences, between the rock bottom of the dead silence, the silence of people in a theatre, for instance, who just have given up so completely that they fall asleep, and the silence when everyone is so keyed to the same point that

there is this extraordinary life, in between the two, are the varying areas where all the questions arise. There are no questions at the bottom or the top; in between is where every question arises.

I think that the only thing that really concerns us in working is to try to know what the heart of the theatre experience is, and to work outwards from it. It's a very strong question: why? Why make theatre? Why impose something of one's own on other people? Or, why waste one's time going to watch other people's efforts? That is the question that's at the heart of the experience. If one doesn't start from that question, then one goes often into endless theoretical discussions about commitment. Am I sufficiently committed? Should the other person be more committed? Should the audience be responding better? These are not primary questions; they're secondary questions. If one's clear about why it's essential to make a certain experience, if one's really convinced of this, then other people can also be convinced. Now, how can one

be convinced about the "why" of making theatre? There is no point whatsoever in going into a theatre space to experience something that you can get outside it. Simple common sense. Secondly, there is no reason for giving one's trust to the people who are performing unless you feel those people are searching for something that they can't find anywhere else. We come together at this moment. You are sitting there; we are sitting here. Somebody asks a question; somebody answers. That's unimportant. What is important is: do we feel that it is worth asking the question, and worth trying to understand the question? It's exactly the same with a performance.

The theatre is about life. What else could it be about? Is it possible in the short time that one spends in a theatre to enter into a living situation truly in a different way, and a more intense way, than if one encountered exactly the same situation in any other part of one's ordinary day? I think that is the only question.

Glenda Jackson responded to the discussion with a story (the following is an approximation, not a direct transcription):

> Always, even in the best theatrical evening, an invisible wall exists between the actor and the audience, or at least the actor likes to think it does. Brook's production of US, which dealt with the Vietnam war, culminated in one of the actors setting fire to butterflies. On this particular evening a woman got up from the front row of the stalls and climbed onto the stage of the Aldwych Theatre. She was a woman in her late fifties, balanced, sane, perfectly sort of middle class. She took the lighter and the box containing the butterflies out of the actor's hand, and she released the butterflies into the air. With tears streaming down her cheeks, she turned to the audience, and said, "I'm not mad, and I'm not a fool. I just believe that there is something we can do." Then she returned to her seat, and a discussion began which rocketed all around the theatre.

[A completely different story about this same theatrical moment (in which critic Kenneth Tynan was moved to shout at the actors on stage) is told by Brook in THREADS OF TIME (p. 124).]

Question: I'd like to go to the beginning: your genesis as a theatre artist. How did you begin? What formed you when you were a child? What was the germ of your becoming an artist?

PB: I wish I knew. I don't think that anything whatsoever comes as a result of clear thinking and clear decisions. I think that whenever one makes a clear decision, it's either wrong, or one goes back on it. I know that my parents had made up their mind that I was to be a lawyer because my brother was a doctor. That was the reason. It was very nice for them to say, "One son is a doctor, so the other son's a lawyer." And it seemed to me, why not? It made sense. I liked going to the theatre, and, to a degree, I liked much more going to the movies, but it never occurred to me that either of these were grown-up professions. It just didn't enter my mind that you actually could do it, until, when I was sixteen, I suddenly realized that it wasn't a grown-up profession to go to school either. So, I left school, and said, "I'm going to go into movies." And my father said, "We'll make a deal. You can go

and see what it's like working in movies on the condition that after a year you go to university." He wisely thought that that would either blow the idea right out of my head, or, on the contrary, cause it to take root. I tried it for a year, and then I went to university, which was a terrible experience.

You see, in the meantime I'd forgotten Latin, and in those days you couldn't get into university without doing a paper in Latin. I had to go back to school to learn Latin in order to go to the university. And while I was at the university, I met a very old lady who said that she was also learning Latin. I said, "Why are you learning Latin?" She said, "Because I want to compose music for the theatre." I said, "Well, what can Latin have to do with composing music for the theatre?" She said, "Well, you see, I want to go to the school of music at Oxford, and to get into the school of music at Oxford, you have to have an entrance paper in Latin. So I'm learning Latin to get into the music school because through the music school I'll learn to be able to compose music to write music for a

play in the theatre." And, I'm happy to say that at the age of seventy-five, she actually did write music for a Shakespeare play played in a garden in Oxford. This gave me an idea that there was perhaps something very interesting to do in a very indirect way, so I went to university and came out of it.

By then, because I'd spent all the time in the university not working, but doing plays and films and things like that, it seemed to be a reasonable career. I thought, well, I must direct. I went to a big movie company, and there was an Italian mogul, a tycoon, who was running this company, and I said, "I want to direct a film." He took me by the hand, and he pressed my hand to his heart, and he said, "Young man, come and work for me. You work for me for seven years, and after seven years you will have learned enough to direct a film." I thought, seven years! You know, that's a lifetime. So I left, and I was very lucky because he went bankrupt the following year. And, in fact, gave up everything and retired into a monastery in Italy.

So instead, I went and worked in a movie company, and then spent all my time going round with scripts. No one would take them. I thought, "Well, what's left? There's something called the theatre. Theatre must take bigger risks because it's cheaper." I went to the Old Vic and said, "Can I direct a play?" And they said, "When you've done a production, tell us, and we'll come look at it." I wrote a letter to a tiny theatre I knew to ask if I could direct a play there, but I thought I must explain to them why it is that I wanted to go and work in such a miserably tiny theatre, so I wrote a long letter to explain why it was that I wanted to come to them instead of a better theatre. And the answer was, "Dear Sir, we appreciate the honor that you're offering us, but we're forced to decline." I then learned perhaps the most valuable lesson for a director, which is that you have to cut things down until you find the level where your work can be accepted. I found a theatre with about twenty seats, in which the maximum that a production could cost was fifty dollars; I mean that was the total production cost for doing a new show. And there was a

tough woman who ran it. She looked at me, and I could see in her eyes, "Here's a young man who's done nothing, and he's determined to direct without any experience. Well, it's worth the risk." That's how it started.

In response to a discussion of disenchantment and radicalization as unavoidable concomitants of participating in theatre, a student asked Brook the following question.

Question: If opportunities are very rare when you share with the performance community the same level of commitment and collaborative energy, and even rarer when you get validation from the audience, how do you maintain your resolve?

PB: I think by forgetting about being creative, forgetting about being artists, and coming back to the fact that there is a very simple level of craft, and that on a simple level of craft one can always lean on the effort to do good work. Basically, you're telling a story. You can always come back to that. You're trying to tell this story well, clearly, vividly, in a way that will increase the vitality of everyone concerned; you can always come back to these very, very simple things, and then from them gradually, sometimes unexpectedly, something arises. People making theatre must never lose sight of the fact that, in one sense, theatres must be full. But they must be full honorably. Now, there's a very big question. To be full dishonorably is easy; to be empty honorably is even more easy.

In one session Brook met with student directors and designers. This question came from a young director with a particular interest in what he considered the "cutting edge" playwrights of today's theatre.

Question: You haven't done a whole lot of contemporary plays by other writers. Most of your work seems to be either with classics or with original projects in collaboration with your group. Do you, as a director, have some sort of qualms about the direction that playwriting has taken, or is it just that your interests lie elsewhere?

PB: I have qualms, that's quite true. I think it is important to do new and contemporary work, and we've done a lot, but always something that's been evolved collaboratively with a writer. Apart from the *Marat/Sade,* it's a long time since I've done an original new play. The *Ik* play, which we developed, came from the contemporary work of an anthropologist. What we're doing at the moment has as its basis these case histories of Oliver Sacks, that we worked on as a team. The reason is very simple.

I think that the theatre is not at its best if it gives just one person's point of view. Because what is the great, great fea-

ture of theatre? I think that the great feature of the theatre is that the audience can enter very deeply into contradictions; an audience can enter into one point of view, fully, and the next second they can enter into another. You can see what you can really do in life. For instance, you go into a bar and you see a man catch hold of a girl by her hair and kick her. It is very difficult for you at that moment to have an equally deep understanding of both of those people. You can't. You have to intervene; you have to do something. You're involved immediately, or you're ashamed of yourself because you're standing at a distance hoping somebody else will intervene. In the theatre, see Othello strangling Desdemona, and the greatness of the play is that you can feel, very, very deeply, and the better the acting and the better the production the more you are really on the inside of both those characters. That's what the whole theatre process does. It enables one to go more deeply into a situation because one's in a different situation than one is in the street. So one can be humanly, infinitely more open than one can be in the street. None of us all day

long are particularly distinguished for being open. Would that we were, but we aren't. We're very seldom truly open, truly generous, and truly receptive.

The curious thing, and I think this is just the sign of our times, is that in the past, conditions of life have made it possible for playwrights to be extraordinarily generous and like novelists. You have a writer like Shakespeare, who has this extraordinary capacity to construct a whole rich world of people. The better the writer, the less you feel that he's manipulating puppets, and the more you feel that in an uncanny way he is getting right into and behind the springs of life in these people. So, a play is not somebody cunningly manipulating people to bring about what he wants to say, but something vastly beyond that, something that seems to have been more possible in the past than today. While you have novelists like Dickens and Balzac and Dostoevsky and Tolstoy, in the theatre you have less. On the whole, I find that most authors are trapped, particularly if they have a certain success, into living up to their success and

producing plays with their thumbprint on them. As much as I find that interesting, it doesn't interest me at all to work on that in the theatre because I feel that playwright isn't truly the servant of hidden realities being brought into existence. He is the servant of his particular point of view, and that doesn't interest me nearly as much as what can happen when one works as a group, bringing and sharing different viewpoints. What can emerge can be more generous in human terms. That's my own experience.

The next five questions, from one panel, loosely addressed "Aesthetics, Acting, and Teaching." Although individual sessions bore technical "titles," in fact, the announced topics were more often than not subsumed within spontaneous exchanges. Questioners here included the artistic directors of two major regional theatres and a theatre faculty moderator.

Question: Those of us who work in the not-for-profit theatre constantly confront the questions: how do we make a bridge to the audience, and who should that audience be? How do we address the question of today's audiences, in a theatre that seems to be run, at least in America, by commercial attitudes?

PB: Don't take anything I say literally, because every place, every situation, is different. I can only talk about my experience in the hope that something in it can be parallel with yours. I can't say anything about the state of the American theatre, commercial or noncommercial, because I just don't know. Perhaps one of the biggest experiences, most important experiences, I ever had in the theatre was when we played in African villages.

We came with a group of actors into a village; the village had no idea who these people were and why we were there. We asked permission to do a performance. We put a carpet down

and started playing music, quite simply to draw people. An audience assembled. What was thrilling in that—more than that, what was revealing—was that if you do that in those conditions, everyone comes. So before you've even started, you look round and you see the whole range of ages. There are the mothers with babies. Because you can't leave a baby, the mother brings the baby. There, the small children. There, the bigger children. You have the adolescents. There are the middle-aged people. You have the very, very old people, sort of elders, sitting together. You have that whole range. That is the audience. And the fact that it's also in daylight means that you can see all their faces. What these experiences make one enjoy and appreciate is the feeling that the more varied an audience, the better that audience is. I say that because in Paris, for instance, the theatre, more than in London, traditionally has specialized audiences that go to certain theatres and certain types of plays. There's an intellectual audience. There's an avant-garde audience. There's a boulevard audience. They're very, very separate, and a playwright leans on that

fact. In London, too, a playwright like Tom Stoppard writes a very cultivated, very intellectual play that depends on you, the audience, having read the books that he's read. It has to be an audience that knows what it means when he makes a joke about Wittgenstein, or Schopenhauer, or Jung, or Freud, so he's definitely writing for an exclusive audience. The pleasure of finding what it is to work for an audience in which there's a bit of *everyone* led us in our theatre in Paris to want to play for low prices and to want to bring into *any* theatre the widest mixture of people simply because that makes a better audience. If you've compared the experience of a specialized audience and a mixed audience, the mixed audience is more enjoyable and more rewarding, and in playing to it you realize that there are two things you have to do to work with a very broadly mixed audience: You have to be clear, that is, you can't mystify, and you have to start finding something that interests all those levels of the audience right away. So, there's a certain simplicity that you have to have, and then you have to go step by step so that you don't lose any of the audience.

This happened in Shakespeare's day with his audience. Ted Hughes, in an extraordinary book that came out last year about the way Shakespeare wrote his verse, underlined the fact that Shakespeare used the word "and" in a very special way. He said that in Shakespeare's day, everyone was very alive and very excited and the whole society was changing and new words, as today, were coming into the language all the time. Yesterday, I heard a brand-new word which was what—"phone talk," or something.

Response: "Voice Mail."

PB: Voice Mail! New words arrive, coming into the language. It was the same in Shakespeare's day. And he loved using them in his vocabulary; his working vocabulary is, I think, up to something like twenty-five thousand words. Now in his audience, there would be the very sharp young university people who would be up-to-date, as you all are with Voice Mail, with all the new words, and then there would also be the simple

people, the thieves, the prostitutes, and the tradespeople in the audience, with a much simpler vocabulary. Ted Hughes pointed out how Shakespeare would, within one phrase, constantly use two adjectives. One adjective was the very refined, exceptional, extraordinary new word that would capture the attention of that part of the audience, while the other part of the audience was saying, "What? What did he say?" So, immediately came the "and," and an everyday word, and in a flash, both parts of the audience were brought together, interested in the same meaning.

I think that in a way the interesting thing is always to believe that an audience has a right not to come to the theatre. I think that one must always feel that if a theatre is empty, it's not the audience's fault. Then one must see that one can draw the audience into the theatre in a *cheap* way; one can take an easy way out. Or, one can say that there are always in existence themes that can interest people. There are always themes that concern people. And then it's a working question: how can

one approach these themes, old or new, in a way that's so simple and clear that everyone can find their way?

The beginning, I think, is very important. The very beginning of a play is where, as in the opening moves of a chess tournament, very often the game can be made or lost. If, at the very beginning, all these people of different ages and different interests and different levels of education can be brought together, then step by step you can go into something perhaps much more difficult than the audience might have thought at the start, and I think that it's only in that direction that one can approach how to fill a theatre.

I say that because very often people have the sad experience of putting on what seems to be respectable. For years, all over the world, it's been considered respectable to do a play of Brecht. A play of Brecht shows that one's not commercial, one's with the avant-garde and politically interesting writing. It's safely left-wing, and all the rest. And the play of Brecht is

27

honorably announced, and people don't come and see it. So it leaves a feeling of anger that they are so smug and inert and complacent and haven't come to see what's been offered them. But the criticism could go the other way, which is to weigh more seriously whether that play of Brecht in this place at this moment has any meaning. And maybe the answer is no, and it's something quite different that's needed.

Brook's interest in Artaud is noted in the following question. Although he does not discuss it in his response, Brook in 1964 mounted an experimental season which was called "The Theatre of Cruelty," after Artaud. It included among other offerings two versions of Artaud's SPURT OF BLOOD.

Question: Artaud had an enormous influence on you, and was a point of departure for you which seemed to culminate in *Marat/Sade*. I was wondering if you could tell us a little about what it was that he sparked in you, and how that continued to influence your work after *Marat/Sade*?

PB: Oh, it's … I wouldn't say it quite the same way. I've never trusted Artaud's ideas on theatre one inch. I'd worked in the theatre I should think for at least twenty years, perhaps twenty-five years, without having ever heard of Artaud. I was in New York, and a lady you may know, Lucille Lortel, came up to me, I think it was at a sort of public meeting like this, and said, "Would you tell us your views about Artaud?" So I thought, "Oh, my God. I'd better find out who this is before the next meeting." I went to a village book shop and found a book of Artaud and read it, and since then I've gradually gotten to know quite a bit about Artaud.

In human terms, he's the most extraordinary, touching, and fascinating person. Very sick. Very sick, indeed. Tragically sick. One of the things that was, I think, central in the experience of working on the *Marat/Sade* was to see that there is nothing romantic about being mentally sick. The idea that this is a form of genius, and it liberates great areas of inner freedom, is just not true. On the other hand, mentally sick people can have momentary and quite extraordinary insights, but basically they live through endlessly tragic experiences. What was very interesting in this very complex man (he was, apart from everything else, also an actor, and because he had a very intense nature and a very powerful look, a strange face, he was a very interesting actor) was that he had a vision of theatre that was totally, totally, totally extreme. I mean, it was as extreme as anyone's vision can be in relation to the theatre.

And I thought this was of great value because of the difficulty of theatre's ever recognizing how quite extraordinary it can

be, and how easily it's possible to settle for a safe, dreary, complacent, ordinarily successful, ordinarily entertaining, middle-class theatre. And so Artaud, to me, from the moment I encountered him, was interesting, merely as the image of a challenge. But if you try to take literally anything that he wrote, and you try to put it in practice, you'll find that he was not a practitioner. Somebody said to me, not long ago, that in the whole of his life, Artaud was only responsible for something like ten or eleven evenings in the theatre which turned out, all of them, fairly badly. That's all the actual practical work he did. On the other hand, you have everywhere the good, safe, honest person who's done many successful evenings all through his life and has never even wanted to go in the direction of Artaud. Well, there are visionaries— Stanislavsky is one, Meyerhold's another, Brecht is another— who have found how to link a vision with craft and practice, and it's very difficult to do. Grotowski in a quite different way in his early work was putting into practice, with tremendous skill and practical knowledge, real knowledge of what the

human being is and what the possibilities as an actor are. He was putting into practice a lot of what Artaud was hoping for. And so I think that Artaud in a way is very interesting still today, if he is taken as a stimulus, but not as a recipe.

In his answer here, and in a response on page 98, Brook refers to a painting by Joan Miró, LE CIRQUE (THE CIRCUS), 1937.

Question: Is there anything in the new work, the work on the Oliver Sacks material, that relates to your discussion of Artaud?

PB: Well, I think it's interesting. Most of you will probably know, when Grotowski started work in the sixties, he had a very simple starting point. He said everything any of us do, every movement that we make, isn't truly the expression of something deep inside ourselves. It is the result of what we've learnt in one way or another. He said that in the theatre, for instance, if you take any of the other, very special, forms of theatre—the Oriental theatre, Indian dancing, Japanese theatre, or European pantomime—all of these are codes that, because they are codes, are sterile. They are fossils; they are not living. All his work was to try to encourage actors to break away from anything whatsoever that resembled anything that they could ever have done in the past—think of this in terms of the sixties, in the way that painters were working, in the way that Jackson Pollock was putting streaks on canvas.

I was looking yesterday at a Miró, in the museum here, which is just that. One's touched by something and it's impossible to say why because it is made out of a color here, a color there, a movement there. Grotowski's idea was that it was possible for an actor to use his voice to find rhythms of speech which are not normal rhythms of speech, intonations of voice that are not normal intonations of voice, gestures of the body that are not normal gestures of the body, in the way that an abstract artist or musician can make pure sound or pure shape. And for this, the actors did rigorous yoga and post-yoga training so that the body was so developed and worked-on, and the voice the same, that the most secret inner impulse could come from far, far away out into the open, and a form could be found that was that actor's total creation, and once found, he could repeat it again and again and again. That was the direction. In his own work this led to an extraordinary period in which he did five or six masterpieces. Then he abandoned that, and for other reasons went into work which

today is nontheatrical and is not linked to presenting performances in public to other people.

Notwithstanding, all over the world, sub-Grotowski groups grew and grew and grew, with disastrous consequences. He's a genius, knowing exactly what he was doing with an *immense* knowledge. The groups that copied him, however, were based in people who had spent two weeks with him, or had seen a video of his work, or had read a book—at one point, there was a man who was in the control tower at Orly airport and in his spare time on weekends was a teacher of the Grotowski method, simply because he, I think, watched Polish airplanes landing at Orly. People were doing something without knowing why and without the "know-how," and imitation Grotowski became one of the most pernicious influences in the world's theatre.

This search for a movement that can touch one through its purity has been, however, in our work, something that we've

never stopped. One of the great contributions by actors from countries with a deep traditional culture, such as Bali or Africa, Japan or India, has been what is quite natural in a body whose organic nature has not been destroyed by twentieth-century influences. And the fact that this organic nature is still available has allowed us to see that an actor can make a very simple gesture; he can just do that [he gestures], in such a way, or that [again], in such a way, that your attention is caught, and you are riveted by something that makes an ordinary gesture more transparent, more clear, more pure.

Now, strangely, while Grotowski was looking for this only in gestures that have nothing in common with anything one does in normal life, we've discovered, bit by bit, that in fact that same possibility exists even in the most ordinary, most everyday, gesture, and that there is a possibility of honoring and appreciating the gesture that has an everyday context. All day long, one can take a glass; all day long, one can take a jug of water, lift it and pour it out, and yet that gesture [he pours

water], and that sound, can be made more transparent. And it's because of that, that *The Man Who,* which is very contemporary and represents a patient and a doctor in very recognizable situations, is at the same time a field in which the actors are looking for that sort of transparency. Curiously enough, it is in a form that couldn't be farther from Artaud, yet is very, very directly linked into the work that started in what we call the Theatre of Cruelty, from studying Artaud through this long, long process.

Brook was asked what he thought a theatre training program should consist of. He turned the question back to the audience, asking them to respond. The following response, to which he then replied, came from a high school drama teacher.

Question: One thing I'm struck with is that *you* study life, and sometimes I think *we're* guilty of studying theatre. That troubles me.

PB: I can understand that. I think that some of the most valuable experiences we've had are when we've gone out in little groups into different situations in life and done pure improvisations. One learns an enormous amount, provided they are pure improvisation, which is not what's normally meant by improvisation. In most cases, when one talks about improvisation, one means improvisation where something has been agreed upon, where someone has said, "Look, you're waiting to catch a train. The train's late, you've got an appointment . . ." You know, there are certain starting points. That's not what I call a pure improvisation. A pure improvisation is very dangerous, needs a lot of practice, and is very difficult. You set out, you come into a place which is expecting you (you have to at least have permission to go into that space), where there are people. You don't know these people,

and you don't know what you're going to do or how you're going to start. But you know that you've got, say, fifty minutes, and you know that you've said to a group of people, perhaps a group of old people in an old people's home, "On Thursday afternoon, could we come and do something for you?" And those people said, "Yes," perhaps a bit suspiciously, and you come. Now you see in front of you people who are partly suspicious, quite rightly, but basically expectant. Now, are you going to betray that expectancy?

Something is expected of you. That's very strong. You can see right away that if you do simply anything—for example, you take this glass and you throw it to someone and the person catching the glass slips over and falls on the floor, and then gets up and gives a shout—they'll look, they'll smile, maybe, and shrug their shoulders. Can you do better than that? Can you in fifty minutes, starting from nothing, create something that by the end of fifty minutes has really made something come alive in that room? It's a tremendous challenge. It

doesn't matter if you succeed or fail, as long as you are not clinging on to what you've worked out, what you hope is going to work. You're really trying to create something at that moment, and to work, it has to be for these people. It can't be something that's for young people; you are at an old people's home.

Early in our improvisations, I remember our going into a mental hospital in Washington. To begin with, to get everyone's interest, the percussionist started playing, which had worked in the past very well. It always warms an audience up. He played too loudly because he wasn't sufficiently with the moment to recognize that, for mental patients, a little noise is magnified, and it became very brutal. He had to recognize that and pull back because he was doing it for yesterday's audience, not for the people who were there. Now this is tremendous, this way of working. You go into many, many different circumstances, learning about life, about people whom you see, whom you talk to afterwards,

who then in turn can ask you to do things, can suggest things to you. There is an enormous effect on your body, your voice, your singing, your invention, your characterization, what those things mean. You can see, in fact, how much psychology a character needs. All those questions come out by being in life. This can really complement what is very closed if one is all the time dealing with theatre questions and rehearsal room conditions. If that is what you mean, I quite agree with you.

A student asked the following, in relation to a discussion of the children in LORD OF THE FLIES.

Question: You've talked elsewhere about human beings being incomplete, and you've also mentioned children as complete. Do you think that is a process that we go through, that we become incomplete as we become older? And that there is a state in childhood that we need to regain as adults?

PB: Yes, this is this whole question of innocence and experience. A child up to a certain age is complete within the possibilities available at that age, but he hasn't fulfilled all his possibilities. He then comes into an awkward period when new possibilities begin to emerge and they stop halfway. And then all the trouble begins. Physically, you can grow up to a certain age. You don't need watering like a plant. You can bind your feet, but otherwise it's very difficult to stop you growing. You just grow, grow, grow, naturally, and then you're grown up. Your body's grown up, but that doesn't mean that your inner possibilities are fully realized. And at that moment the innocence is lost and you go into complication, and every problem exists. What you have to do is to go through them

and develop to a new innocence. It's not the old one; that would be too easy. I mean, you see people with all sorts of brain disease who become children again. One can't say that being like a child is really an aim for an adult, but at the same time being like the adult that we all are isn't enough. That's why so many writers have used the image of going through a forest; there's the childhood and then there's this going through a forest which often is very dark and tangled, and *if* it's possible to get out of it, then a new form of what you can call innocence is found. One innocence is given; the other is discovered.

This question, also from a student, was asked during the opening session.

Question: Since the beginning of time, people have been walking around and saying the end of the world is near. A similar cry is that theatre is dead or dying. Is theatre going toward some sort of a cataclysmic end, is it going through another metamorphosis, or is it just going to be the same, as we keep asking the same questions about why we are here?

PB: I think that's a perfect example, if I may say so, of a false question. Not yours, but the question: is theatre alive or is theatre dying? It's just quite simply a false question for two reasons. One is so what? What can we do about it? Who cares? That's one side of it. The other side of it is, supposing today somebody here asks the question: are meetings of this sort dying or not? In twenty years' time, will people be sitting together talking in one room? Again, who cares? We at this moment, and no one else, are here in this room, and what we make of the little time we have together is our question. I think that's the only way you can look at theatre. Really, for the rest, let sociologists, futurologists, write what they care, but not waste time on useless questions.

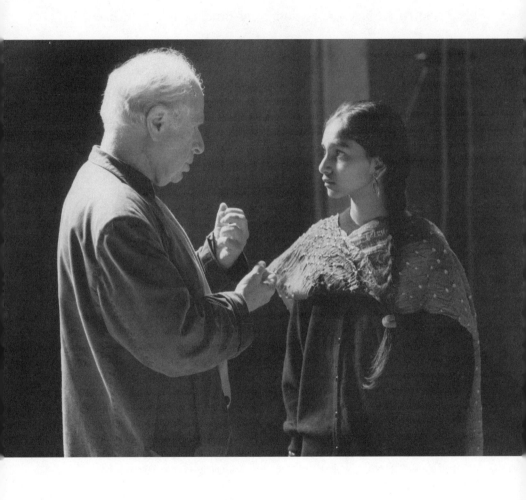

II.

Acting and Directing

The Tempest (1990/1991)

"... when we were doing *The Tempest*, there was one essential role for which no one in the group ... was suitable. Miranda.... the whole meaning of the play depended on this girl, who's been brought up by her father on a desert island and sees human beings, apart from her father, for the first time in her life at the age of thirteen or fourteen, being played by a girl of that age." (p. 60)

Photo by: J. Bétant

My attempt to separate Brook's responses into clear topic headings was, often, frustrated. A part of Brook's brilliance is the integration and interaction of his artistic skills; a part of his artistic power is the integration and inseparability of his gifts as both director and designer. These gifts operate simultaneously. It is similarly difficult to separate his considerations of acting and directing. Only to make the content more manageable and its information more accessible, I have isolated his discussion of design elements as a separate section.

The following questions were asked by student directors, by the regional theatre artistic directors, by professors of theatre, and by the general public. They are drawn from four different sessions.

Question: How do you resolve the problem of not having enough money to do what you've found necessary to do?

PB: I don't think that I've ever been in that situation. Not because I've had lots of money to do things, but it's always seemed to me that directing is this marvelous link between the ideal and the practical—that every director has to have both. If he hasn't a dream, or ideal, or vision behind what he does, what's the use, and if he's only what stage technicians and producers most admire, which is a practical person, what's the use of that either? Directors have to be both. But the practical side of directing, and I think this is almost, you could say, the test for a director, is using available means.

I can put it another way. I think that the more you direct, the more you see that you need longer and longer time, that it's really good to have a long time. I've fought for that. But if at the very same time, one doesn't realize that if need be you have to be able to say, "We've got to make a performance out

53

of nothing in three hours' time," then you can't use the long time well. Even if you have five years to make a production, if within those five years, at each rehearsal, there isn't the sense of improvisation, in the sense of using the moment, the five years will lead to a very turgid result. I've seen productions in Moscow, in the old days when they would rehearse for three or four years, which looked as though they could have been done rather better in a week.

It is exactly the same thing with money, with spaces, with available means; one must cultivate those two things [the ideal and the practical] at once. I find the same with films. I have never been in the position to make a commercial film because I've always wanted to do subjects that from one point of view or another are commercially difficult. So I've always had to work, not the way that normal filmmakers do, which is to have a subject and then a production manager who makes a budget, but the other way around. What is the most money that we can get? Okay, we'll do it for that sum.

For those of you who'll see *Lord of the Flies*, the whole adventure of that film was starting with a big Hollywood producer who wanted to make it for several million dollars and who found that he wasn't sure of getting several million dollars back, and dropped it, and then going round until I found a producer who could get together, *just* get together, two hundred and fifty thousand dollars, which wasn't enough to do any part of the film, all the time finding and inventing shortcuts to be able to do it. I think that there's no other way of looking at this. Where you can see that an audience senses whatever scale you're on, if you can appeal to that audience's imagination because the audience sees that you have been compelled to use yours, they are more touched than if they see that you have every technical resource at your fingertips. An audience looking at one of the giant musicals thinks, "Well, if I too had eight million dollars I could do pretty well," but when they see that balance between the things that are necessary and the added element coming from the imagination, then one's touched. One thinks, "Well, perhaps I couldn't have thought of

that." Do you see what I mean? Does it correspond at all to what you mean? I think that this is very, very important.

It's also important, I think I'd almost say politically, that a director realizes that at the very *worst* he can still direct. Susan Sontag has just gone to Sarajevo, doing *Waiting for Godot* with Bosnian actors. In this cellar the only lighting is a few candles. There is no other way of lighting the performance, and it has to be in the cellar because it's too dangerous elsewhere. The audience who come to see it sit in the cellar. But out of that a production is made, and that is directing. When I say it's politically important I mean that if one doesn't accept that, then one can rapidly be blocked by a sense of frustration or bitterness. You know, "It's all very well. Peter Brook's here but he had the Royal Shakespeare Company, and all we had was ..." and whatever. This is all true up to a point, but behind that, the fact is that if you are a director, you are "the one." The actors can be discouraged, everyone else can, but you are the one who uses available means. I heard a story just the other day of

a German director who was in the middle of rehearsing some big production at Hamburg and his leading actor fell ill. The next day he found a completely different play that could be cast by all the rest of the company, and they went on rehearsing and made the opening. That is part of directing.

Question: You have spoken of starting the story simply and involving everyone, and then leading to something more complicated. Is that behind your taking your work while still in rehearsal and playing it for school children?

PB: That's a very perceptive question because that is exactly why. It is because we can so easily fool ourselves that we often in rehearsal go and do a quick, unprepared, improvised run-through of what we're working on for a group of school children who know nothing about what we're doing. It is really to see whether we've found the way to capture their interest. And if we haven't, then it points very strongly to where we've gone wrong.

I think that every new production over years and years has been transformed by that experience. The condition of the exercise is to leave behind every physical thing that you've worked out for the production, to take no bits of costume, no furniture, no props, nothing at all except what has been rehearsed. The group has worked long enough to share now what the story is about, to come into a space which is nothing like the space where you've been rehearsing, or where you're going to play. Here are fifty, sixty, eighty kids sitting arranged around the walls. And then, completely improvised, but using every word, every detail of the play itself, we play for children. We did that with *Cherry Orchard,* and the next day the entire physical production was completely transformed and liberated by that experience. We did it with *The Mahabharata,* and it was perhaps the experience that gave the most confidence to everyone who had no idea up to that moment whether this old Indian epic could make sense to Western children. Here we were in a school where not one child knew anything about

us; we didn't even say what we were going to do. That's another condition of the exercise. We just start doing it. We did the same with *The Tempest,* and, there, every physical, real, insuperable problem was solved, magically, just by feeling what was making sense and what wasn't making sense. I think, on the whole, in two hours you gain two months of rehearsal by playing once to children.

Question: You have a company of international actors. How do you choose your collaborators?

PB: Well, my closest collaborator for twenty years is sitting here, and could perhaps answer because amongst other activities, Marie-Hélène [Estienne] has this interesting and difficult role of finding actors for particular projects. As you can imagine, with an international group one can't go about casting like a movie, through an agency. People have to be found in very different, very special ways.

First of all, there's the project itself. For instance, when we were doing *The Tempest,* there was one essential role for which no one in the group that had worked together for many years was suitable. Miranda. It seemed to me absolutely essential to have a very young Miranda. I'd seen Miranda played by actresses of twenty-five, twenty-eight, or thirty, but it seemed to me that the whole meaning of the play depended on this girl, who's been brought up by her father on a desert island and sees human beings, apart from her father, for the first time in her life at the age of thirteen or fourteen, being played by a girl of that age. An experienced, older actress can only give an artificial image—and the reality of the person in this play is more important than the invention of an actress. It's not the same, for instance, with a much more complex part like Juliet, where you can enter into the role in many different ways. Miranda really needs a very young girl who, even in her body, you could see is brought up in a way that's different from the way that people are brought up today—people who can sit like the girl in front of me [indicates a student in the

front row]. It wants a Miranda who in no circumstances could have been brought up to sit like that in front of her father. And so it was through that necessity that Marie-Hélène found a very young fourteen-year-old Indian girl, who'd been very strictly trained in Indian dance by a marvelously imaginative but very, very strictly conventional and traditional mother, and a second Miranda, a half-Vietnamese girl. Both of them brought something that no Parisian or French girl could have brought to the part. This happened because there was a necessity, and out of the necessity it was necessary to look in different ways.

It's very simple, if we're talking about actors. An actor must have two qualities, not one. He or she must have innocence and experience. I get letters from actors and actresses to say, "I'm very young. I've done nothing. I'm completely innocent. I want to put myself in your hands; you can do what you want with me." The answer is no thank you. Then there is the experienced actor who says, "Well, I've done this, I've done that."

We've just been working in Berlin; there the directors say that the attitude of a good German actor today, a young one as much as an old one, is: he comes to the first rehearsal and his attitude is, "Tell me what you want me to do. I'm an experienced actor, I can do anything whatsoever. Don't ask me my opinion, don't ask me to collaborate in any way. You say what you want, and I will do it magnificently." That is the other extreme. That's the experienced actor, and the only answer to him is no thank you.

Glenda Jackson, sitting here yesterday, was talking about the fact that it's possible for an actor to be very experienced, to go through all sorts of shaming and humiliating experiences in the work that he's asked to do, and yet retain an essential innocence. And that is true. And I say that what one always must find are actors who are totally naive on one hand, uncorrupted in some way in their feeling, and yet have a know-how, having been toughened by experience and having something that they know how to do. Otherwise, they're really no use in a group.

Question: As I look up at this particular constituency, I see young actors whose work will be tomorrow's theatre. They are here to explore themselves, as actors, and to explore the possibility of a participatory role in theatre, to avail themselves of what we call loosely and perhaps inaccurately, training. My request is that you speak to them.

PB: Whew. [Long pause.] I think you can only explore yourself if you're not interested in exploring yourself, but in exploring other people and exploring your relations with other people. The first thing that can really destroy the true possibility of an actor is that he's too interested in exploring himself. A sensitive actor can find himself, for instance, in a very tough and brutal group; he may have a real ideal, his innocence may still be there, and he looks round and he sees that the director is vulgar, the other actors are exhibitionists, and all that he has longed for in the theatre is being betrayed before his eyes.

This happens all the time, but at this moment he has a choice, and the choice is either to retreat behind his judgment of the others, or to say, at every moment, "I have a possibility." Maybe in this rehearsal everyone's making noise. "I'll try to listen to the other person a little more acutely. I'll try to see what tiny development I can make in my relationship with one person, with two people, that I'm working with. I can see, if I have to wait, whether I can wait more keenly, watching what the other people are doing, unlike those who are sitting around, clearly uninterested in other people's work." And I've seen several things come out of this. I've seen how one person alone in that way can imperceptibly have an influence on a whole group and how after a certain time a whole group can be a little more attentive to one another, just through one person's sustained attitude.

I remember when I first worked with Glenda Jackson, the very first time, when I hardly knew her. What struck me most was that Glenda Jackson was a very, very withdrawn person,

and in life incredibly sarcastic, very tough and sarcastic. In rehearsal she would sit always huddled up; she would put on the worst possible clothes, in a sort of defiance, and she'd have a big scarf that she'd wound round and round, a little cap that she'd pulled down, and she'd sit huddled up in a corner. But from there she was watching, with care and interest, every single thing that happened in the day. When there were moments when we would meet or discuss, out of this silent figure would come a comment which was so accurate that it illuminated everyone's work. But it was never to do with herself. Well, I think that that is something that is extremely precious to develop for a young actor, and to see that as acting basically is to do with relationships, the possibility of developing a relationship is always there, in the best or in the worst circumstances.

One doesn't depend on the great play, or the best conditions, or the marvelous director. One depends on oneself. And that is what one can bring. That's one thing. The other is that this

exploration of oneself depends partly on what one has in oneself, but also partly on the stimulus that comes from outside. One has to be stimulated. Left to himself, in the end, everyone will go to sleep. One can't act on a desert island. The actor the first day will say, "Well, I'm going to be great, and get rescued one day, so I'm going to keep my acting going." And so he gets up and does some yoga exercises, he does some Tai Chi and he starts reciting long monologues to the palm trees and to the monkeys. On the second day, he does a little less, then he gives up. And when the ship comes to rescue him he has completely forgotten about his acting. Because one can't do it alone. One needs to be stimulated and provoked.

That's what a director is for, partly. That's what the other people are for, partly. That's what a good part is for. You can improvise just so far, and if you improvise around a good part, the part itself takes you beyond yourself. Any part must be partly you and partly not you. The part that is you is easy, but

the part that is not you, you have to discover. And you have to take that as a challenge. Now what I mean by that is this. I think there is one thing that I have found that can help every actor in every part he plays: that is for him to believe, by some basic act of faith, that whatever the part is, the part is greater than he. I say this because it's rare; I think you'll find that most actors, and particularly actors playing small parts, look at the part and look down on this person and say, "Oh, yes. I see him. Well, I'll do this with him." In other words, he sees the part as being a person less extraordinary than he feels himself to be. And so he is going to use his imagination to take that poor guy, that poor woman, and transform that poor individual, that thinly written character, into something as great as he is.

The other way of looking at it, even if it's false it's true, is to say that if you're just playing an idiot, if you're playing a witless cretin, that witless cretin is more magnificently witless and more cretinously cretin than you can ever be. If you once recognize this, then there is something that you can work on,

continually, because you realize that there is a stretch of your body, of your understanding, of your imagination, of your feelings, to find something that is beyond your natural range, and that creates a tension and a friction that in the end can produce discovery. That's all I can say about it.

Question: Mr. Brook, what was your experience, or your feeling, working with such young actors in this film [*Lord of the Flies*], and what are your feelings about working with young actors overall?

PB: Very different between the cinema and the theatre. In the cinema, all that matters is somebody being true once and for one moment. There have been thousands of films with children who are always astonishing because, apart from the children who for some reason are inhibited, a child can very easily be brought to be completely true to himself. So, it's not a coincidence that really every year there's a film with an amazing child in it. And in a way it isn't difficult; you just have

to have a good relationship with a child, a confidence. You've explained the situation and the amazing thing is that even if the child does something that from Lee Strasberg's point of view would be psychologically wrong, it becomes right because he's done it. Just as in life. If you're sitting there quietly [indicates an audience member], and you suddenly scream and jump up on your seat, we can't say it's out of character because you will have done it. So then, it's you in a different, in an unexpected, way. And that's the same with children. Children can do surprising things, and they become right because there is something in them that is complete.

In the theatre, the difference is that you then have to have a sort of skill, and a knowledge, to be able to take this quality and turn it into something which is not easy, and not a natural thing to do. You must make it big enough to fill a space. To work at the pitch that can fill a big theatre is something unnatural, so it needs a special skill. To do it every night also needs a special skill. That's where there's the big difference.

Question: I've heard you speak of your response to an actor in the atmosphere of an audition. I wonder if perhaps you would discuss that.

PB: I think the greatest enemy of good theatre is a table. You come into a room to audition, and then later, to rehearse, and the director is sitting behind a table, and the bigger the theatre the longer the row of tables. What sort of human relationship can come out of that? It's clear that the audition in which somebody is brought on, does his piece, and is either witnessed by someone behind a table or somebody in the distance in the dark, or several faceless people in the dark, may sometimes be a necessity; sometimes one really has to work fast and there's no way out of it, but it is a shameful process. I mean, it's something that we've done often enough, I must say, with singers, because one doesn't consider singers in the same way that you consider actors. This isn't completely unfair because with a singer, apart from when they're frightened and you see at once that you have to put them at their

ease, there is something very, very precise that a musician can hear quite directly: the timbre of the voice. If the person isn't nervous, the casting is related to vocal timbre—somebody consistently sings flat, somebody has a very ugly voice, somebody just can't sing at all. When you have singing auditions you go through all that, but it's very clear, at the start, when somebody has a beautiful voice. That emerges in ten seconds, in the cruelest of conditions. So, very often, when there's no time to waste, one can see a line of people; after that, though, you can't go any farther.

If you then want to know how sensitive that person is, how that person can relate to someone else, you can't any longer do it by just sitting like that and saying, "Thank you very much. Would you do this or that?" Whenever there's a need to explore actors seriously, for a real purpose, one has to replace audition with working sessions—working sessions where one has several people at once, where one actually works, say a half hour, with each person. If you've got five

people, that's two and a half hours. In two and a half hours with five people, you can do a big variety of things. You can start with exercises which make that small group feel more at home, more relaxed, so they can begin to relate to one another. Then one can take material about which each person feels less judged. Then one can create situations which are enjoyable—where people laugh, and the audition is no longer torture. Out of that, at the same time, you can see how people work; they can see how you work. This means that if, at the end, somebody feels, "This isn't the sort of work I want to do," they have a good escape. If you feel that this person and the person you are looking for don't correspond, and you are forced to say, which is awful and always very painful, "I'm sorry, but it's not going to work," they will not have wasted their time. If you've done work together for two and a half hours, your morning or your afternoon isn't wasted. You've had an experience, and so there isn't that frustration and bitterness, that unpleasant feeling of just

coming from an audition and being rejected. I think that there is real meaning in a working session from everyone's point of view.

Question: There often seems to be, in our theatre and in our training programs, a kind of tyranny of psychological realism. Why is your work the exception in terms of exploring many different ways of perceiving and behavior? Why are we so bound to the here and the now, and a Freudian approach?

PB: I think there's something that has to be looked at very clearly there. Gertrude Stein wrote about Picasso that very few of us actually see with the eyes of our time. We actually look at our time, but because of all the memories, all the conditioning in our brain, we see with the eyes of yesterday. She wrote this at the beginning of cubism. When Picasso sees, as a cubist, he's not seeing with the eyes of tomorrow, he's actually seeing quite directly with the eyes of today, but it

shocks people because they're still locked in the vision of yesterday. I think this is very true, but where this can produce a misunderstanding is that a painter can be ahead of the vision of his public; he can be misunderstood, and his work can wait for the eye of the public to catch up with him.

On the other hand, within the theatre, one must recognize that this here and now is the lifeline, that if here and now the audience isn't with it, they never will be. There's never a second chance. It has to happen. Now, what this means is that the audience, to be interested as they look at the performance, must find something that makes them feel that they and the performer have something in common, which is why even very simple things [pours water] like filling a glass can be interesting because everyone knows what it's about. So, even the psychological realism has its place. Somebody walks in here, the other person looks at him strangely, and the first person begins to question him and say, "Why are you looking at me in that strange way?" You can catch everyone's interest

because at once there's something that we have in common. That ordinary level of theatre has to be accepted; people, in one way or the other, have to seem real. But, and this is where I think the whole question is, not *too* real. Come back once again to Shakespeare. If you take *King Lear* and you apply a psychological realism to the part of King Lear, you can do the opposite of what I was talking about a moment ago; you can bring him down to a very ordinary querulous old man. You can work that out psychologically. You can work out the problems he has with his daughter, the problem the daughter has with him, the problem between your own father and yourself or you and your children. You can work that all out and out of that you can think you understand *King Lear.* If you do that, you are being superior to the play. The director, just like the actor, is pulling the play down to a very ordinary television drama because he isn't thinking of the play being greater than his own imagination. He's bringing it down to his imagination; his imagination is fed up to there with all the clichés of today about Freud and psychoanalysis

and everything else, so he is bringing his baggage, which is 90 percent rubbish, to bear on something which is much greater than that.

On the other hand, if he says, "I don't need to understand this character in detail," he's like an old-fashioned actor who says, "Well, you just have to boom the words and the character will take care of itself." That is equal rubbish. So what's in between? In between is the fact that you recognize that you have to try to understand this character as a real human being, and yet this human being has a motivation, has a uniqueness, that is way beyond the ordinary; he has to be understood, but the everyday psychological understanding is not enough. Once you've faced this, then you are forced to go beyond. You are forced to find what can make this character unique to an audience, so that they recognize that there are hundreds of thousands of angry old fathers in the world, but only one King Lear. What makes him unique all through history and all through the world? Does that mean

that he is not a human being? No, he is a human being, but a unique human being. What does that mean? Then you have weeks and months of work.

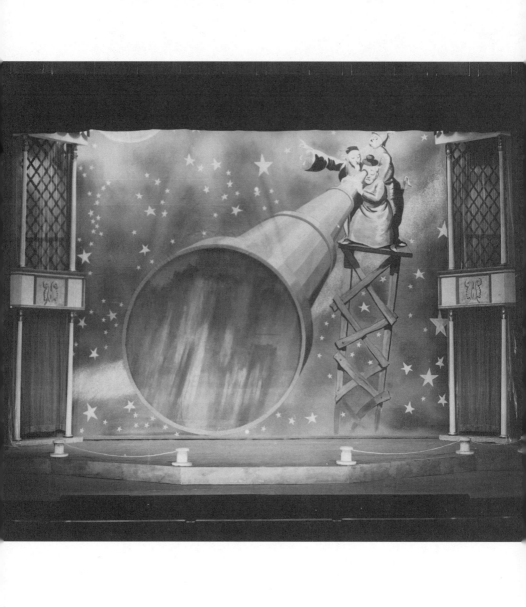

III.

Design

***Love's Labour's Lost* (1946)**
"… it seemed to me that what happens inside the picture frame had to be made
as fascinating as possible. So, from the very start my biggest interest was on the
design. It seemed to me that the image that you saw through the picture frame
was the image of another world. … It had to be exciting
because it was unexpected." (pp. 83–84)
Photo courtesy of: Shakespeare Centre Library, Stratford-upon-Avon

T he following question opened the special session in which Brook met with undergraduate directors and graduate designers.

Question: My question is related to the style of your work as it has seemed to me to simplify in form through the years. I'm wondering if you see that arc of simplicity in your work, and how your refined aesthetic has impacted your relationship with your collaborators?

PB: I'm happy to be with you, and very ready to talk about any experience I've had that may be useful to you, but on one condition: that you watch very carefully anybody speaking about his own experience. An experience of the moment is the result of where one's been born, how one's grown up, what one has lived—so one must always be very, very careful of taking one person's conclusions literally because that can never help anyone else. It's only if you can see it as a parallel metaphor that can be applied in a certain way that it can be useful. So, as long as you all promise not to take anything I say too literally, we can talk very easily.

When I started work, what horrified me most in the theatre was when I heard people talk about simplicity, because in

England at the time, the critics, and particularly the academ-
ics, had a passion for bad, amateurish work. If the work was
truly bad, was weak, was feeble, but somehow in a Puritan-
ical way showed good intentions, it was praised to the sky.
And the ultimate praise was simplicity. As somebody young,
working in the theatre, I'd go and see simple productions of
Shakespeare. A simple production of Shakespeare meant quite
simply having what used to be called a traverse curtain—you
know what that is. In the middle of the stage there's a set of
tabs, usually very drab and ordinary ones, that would open
and close. That solved the whole problem of staging Shake-
speare because you do one scene on the full stage and at the
end of that scene you'd close the curtains and people would
come on the little shallow bit that was in front of the curtains
and do the next scene. While they were doing that, behind the
curtain somebody would lift a table out and put the throne in
its place, the tabs would open again, and that was considered
the most magnificent solution for all the problems because
the play spoke for itself and it was simple. And I looked at this

as a young person who only went to the theatre in the hope of finding great vitality, and there was no vitality at all. It was just a drab, lifeless presentation of these old plays in an old way with people standing in obvious positions. The person who had most to say stood in the middle and then people stood symmetrically on either side. And when I went to France, it was even worse, because those positions were numbered; the stage was divided from right to left, one, two, three, four, five, six, and the rehearsal of actors was to go from number two to number three, then you go back to five, and then four comes forward to one, like a chess game. And, these famous plays that I'd already read and loved didn't come to life. So at that time, I didn't have any reason to question that theatres were what theatres seemed to be: buildings with a stage, an audience sitting in darkness, a picture frame, and then an area behind. I hadn't any reason for questioning that; that's what, ever since I was a child, a theatre had been. Because of that, it seemed to me that what happens inside the picture frame had to be made as fascinating as possible. So,

from the very start my biggest interest was on the design. It seemed to me that the image that you saw through the picture frame was the image of another world, and that the whole work of the theatre was really like making a movie, a stereoscopic movie, a big solid movie, in which the people sitting in darkness were taken out of themselves and were excited and fascinated by what they saw. So, of course, it couldn't be simple. It had to be exciting because it was unexpected.

I think from the first I had an intuition that the actors had to move and bring vitality through their physical movement, through the way they related to one another, and through the freshness and unconventional nature of their acting, to get away from this boring theatre of people standing in rows in one, two, three, four, five position. The main things that stimulated me were the elements of this other world behind the proscenium—the lights, the colors, the stage movements; all of that thrilled me. So, for a long time everything started from

an elaborate use of all that theatre could offer. And I found this stimulating, exciting, dynamic; I rapidly learned that the image that you are looking at couldn't be too complete. If it was oversaturated, the imagination wouldn't flow anymore. The image that you looked at had to suggest a real world without being completely a real world. That seemed immediately clear. In the work that I did with a designer, or sometimes by myself, everything depended on finding a physical basis that was like the key to the play. It was, to me, very clear that if in the preparatory work one found a shape or series of shapes that were like the blueprint that an architect uses, in other words, were shapes that didn't allow the play to grow, whatever one did in rehearsal, the play would never come right. And if, mysteriously, intuitively, alone or with a designer, one found the right zigzag, the right number of doors, the spaces that were like the skeleton of that particular play, from then onwards rehearsals were easy, and the more apparently difficult the production I did, the more it was easy to do.

So, I was always nervous on the first day of rehearsal because, until it was put to the test, there was no way of knowing. Had we reached this point where what we'd made up as a model was not only the skeleton of what the play needed, but was giving the dynamic possibilities that the play needed? I remember seeing early productions. I went to Hamburg just after the war; it had been bombed, and the whole audience was on the stage of the opera house, so you had an enormously wide audience, and a very, very flat playing area. I saw *The Barber of Seville*. Because everything was very shallow, they had to build a set that was based on width; it was a whole series of windows, staircases, and doors, going over an enormous space, and the moment I saw it, before the show began, I knew it was going to be an extraordinarily lively production of *The Barber of Seville* because anybody could direct the play from then onwards. You knew that somebody could appear there, somebody could come in here, they could run there; you knew that the actors would immediately explore and develop these possibilities by themselves.

Again and again I found this. I also found the opposite, on a production of *Hamlet*. With the designer, I settled for a circular platform that looked very good on the model. But I had a funny feeling. I had a curious feeling: this isn't going to be right. The designer and I worked well together, but he worked very fast. We went through the scenes and he said, "You can do this scene here, you can do this, you can do that." He argued me out of any objection I could find, except this intuition, and the moment we started rehearsal I knew that we could never do a good production.

Now, if you're a director you have to conceal this to a degree from everyone, including yourself, because you have to go on to the end. But there it was hard work, hard work against a brick wall, because with this circular platform you could never get good relationships with people. The dynamic relation that a play needs for people to come and go in one scene, leave in another, was blocked by a formal set that imposed symmetry. Every entrance, every movement, was blocked by

this particular circle. For something else, a circle could have been magnificent, and I knew then what I couldn't have expressed earlier; I knew that my resistance was not for any logical reason, but rather for sensing that the circle wasn't the skeleton of this particular play.

One other concrete experience before jumping on, otherwise we'll be here all afternoon and night. I was doing *Love's Labour's Lost* at Stratford. It came third; there were two other productions before it. The first production of the season was an experienced director doing a production of *The Tempest*. Normally, as you know, directors seldom see how other directors work, but as we were in the same theatre, and I was very interested to know what he was up to and what the first performance was going to be, I crept in one evening. It was just before the last rehearsals where they were having what in England was called at that time, I don't know if you have the same jargon, the dress parade. There was the designer sitting with the director, and all the cast was coming on with very

elaborate Elizabethan costumes. He was doing *The Tempest* in the style of a masque, with extraordinarily complicated, romantic scenery. The actors came in one after the other in the most magnificent Elizabethan costumes, with velvet and feathers and ruffs, and I sat there secretly very jealous, and thought, "Hell. What's our show going to look like in three days?" Because we'd done it, in fact, in costumes that were based on Watteau, which were extremely pure and simple, in just one shape, that was beautiful because of the way it moved. I thought, "It's going to be nothing compared with this splendor." I sat there, seeing one costume after another, and truly admired the magnificent work of the designer. Three days later there was the opening, and it was a near disaster—not because the scenery changes didn't work, things fell down, and all the things that can go wrong did, but most of all because every costume that had seemed in the dress parade, where there was no other meaning but to look at this costume, to be magnificent, within this great complex play unfolding, now looked not only excessive, but also increasingly ugly, until by the end of the show,

The Tempest had not appeared, and the designs no longer looked like good designs. I learnt that moment a lesson for the rest of my life, about looking at costumes out of context, or, later, looking at lighting out of context. It was one of the most interesting and important subjective experiences, to see how, in the theatre, anything to do with design is inseparable from the fact that theatre is not a static image. It is not even an image in movement; it is a play in movement. It is inter-relationship within something which unfolds like a great spool of film. From the beginning of the play, and at each moment, image, sound, movement, word is having its effect on an audience, bringing the audience closer to the characters, more into certain human situations, bringing their interest up, then lowering it for a moment. It's out of this rhythmic structure that every element takes its place, and I began to see that this applied to lighting as well.

I love doing lighting. In the last days of rehearsal, I would sit with the electrician, and we'd work through the night for sev-

eral nights before the opening. At four in the morning we'd do the most exquisite lighting cue. At five, six in the morning we'd go home, and then the next morning, at ten or eleven, the cast would come in and we'd do a run-through, and I couldn't believe that I had the same pair of eyes because I'd look at it with sort of shame and horror. What had, in an empty theatre, been a pure, mysterious light show, in the flow of the story was idiotic. And we had to spend the next night relighting, which mainly meant cutting out nine-tenths of the cues and bringing everything about twenty times brighter.

Now, to make an enormous jump—gradually over the years, through experiences, the human contents of a play become more and more central to me until it became absolutely necessary to explore this by going *outside* theatres. There was a time when I thought, I can't go any farther with the work that I'm doing unless I can put into question what I've accepted all my life, which is audience, stage, picture frame or thrust stage. I want to see what happens if we're in something infinitely

more basic—which is just human being, human being and nothing else. Just like we are now. Just together. So, we started a whole chain of experiences and experiments—with travel, with different sorts of groups, with children, in Africa, in the East, here in this country, improvisations, tiny performances based on themes, exercises—but all of them were to see what this central element in theatre, which is the human being, can do without any help. That's where my work changed.

While today I wouldn't deny anything—lighting, or costume, or sound, or music, or technology—the starting point has been reversed. The starting point once was a picture, a picture which must be filled excitingly so something then can be carried by that picture; it's now the other way around. Here is a human being, other human beings watching. Now, can we tell the whole story we want to tell, and bring to life the theme we want to bring to life, doing no more than that? Sometimes the answer is yes and sometimes no. It's not enough just to be sitting in a pair of pants and a shirt. There's

something more that's needed. And that can lead, and we have been led at times, to use all sorts of elements.

Just recently, I had a very difficult experience. Having heard from so many people, and reading in print, that whatever I do is simple, I'd now become this thing that I'd so hated. I started to do a production of an opera, of *Pelléas,* in our theatre in Paris. The theatre in Paris is the most magnificent and thrilling space when it is empty. The walls are beautiful, it's full of life, it's got a beautiful proportion, and I thought, "Here is an opera of great purity." I talked to the designer, Chloé Obolensky, with whom I've worked a lot, and I said, "It's very clear, we just want to do this with nothing. Just our space, really, with nothing brought into it, is all we need." I started with the idea of simplicity.

We did a first month's work, and then we took a break, and then we picked the production up again. During the first month, we started with simplicity, and the simplicity, at the

end of the month when we did a run-through, wasn't simple. It was bare. It was arid. It was lifeless. And I found I was there, now part of that whole crowd who start off by doing simple productions. So then we started again, a few months later, and this time the designer brought in hundreds of bits and pieces, and we started with a great clutter of elements that could have served for this particular production. We were doing it with pianos, trying to get a feeling that came out of the piano music of Debussy's time. She brought in not only chairs and sofas and little tables and the goldfish bowl and things like that, but even great potted palms. One day, a truck drew up to the theatre, and all these great trees were unloaded. This empty space was full, and then we started working in it. And for the first few days it was marvelous because they gave us thousands of ideas and possibilities that we couldn't have had before. And then we began to clear away the clutter, take away what seemed to be ugly, heavy, unnecessary, and gradually it all disappeared, leaving us with some carpets, two pianos, a few chairs that proved absolutely

necessary to bring certain scenes to life which had defeated us when there was no furniture, two little ponds, two little pools of water which we'd felt early on were right, but we'd never been able to find the place for them. Through this it was suddenly clear that it was *there* and *there* that they must go. We kept one thing that had been there from the first day, which was the goldfish bowl, with real goldfish in it. All the rest went away, and what happened when we put the show on, after all of that? Everyone said, "Oh, it's simple." So, that's the whole story.

In the following questions the content moves back and forth between directing and design. Because that interaction is essential to Brook's work, I have not attempted precise editing in order to adhere to the titles of these discrete sections; rather, I have let the chips fall as they fell in the dialogue itself.

Question: If you feel very strongly what a play says or is about, and yet there are forces, like a designer, or actors, or the audience, that go against your vision of the play, how do you reconcile your fear as an artist that you may be wrong, and that if you produce this work as you see it you could be failing to serve the play? If later you change your mind, do you do the play over?

PB: Well, the feeling that you may be wrong is there all the time. I don't think that that's opposed to having convictions. What is very unhealthy is to believe in your convictions for more than a second or two. You have to believe in them for a moment, otherwise everything is so weak. You have really to have two hands. One hand will say, "I'm convinced," and the other hand will say, "Steady, that may be completely untrue." Everyone must work in this spirit. If you do, I've never known a real difficulty of communication, outside of a few horrendous experiences, mainly with opera singers. First of all, you have a hunch, and you take a play off in a certain

direction. It is formless. That's what one must insist. Formless means that as you start the day you are convinced that this form may be the answer, and by the end of the day you recognize, you and the actors who've all collaborated together in looking in this way, that it isn't. So, we've lost a day, but it isn't lost at all because you'll find that five days later something in that day comes back and is priceless.

It is a process; there's no other word for it, like the process that there is in a painter, particularly an abstract painter. I was just looking at a marvelous Miró [see pp. 34, 36] there in your gallery—a painter who will do "this," and then because of that, he will come to "there," and because he's done that, he looks back a bit and rubs it out, and does "that." That's what I mean by a process—where it's going up and down and changing. It has moments of total despair for you and the actors together, where you believe something and they don't, or they believe something you don't, or you both face the fact that it's not going in the right direction, and you go away and

you come back to it, and you start working again. That is the process of growth, and it is a risk you take. There *is* an element of risk; you may be completely wrong, like the *Hamlet* I was talking about [pp. 87–88]. I had to go on day after day with that sinking feeling that we were committed and that we had to deliver something. I couldn't say to the actors, "We're going to call it off." Often you feel like that, but have to go on, and in the end you may get there, and you may not. That's part of the normal risks. The most important thing for everyone, I think, is to be able to affirm and yield. To affirm strongly, otherwise your work is weak. And to yield willingly, otherwise you're pigheaded.

Brook's film version of KING LEAR, referred to in the following question, was made in 1969 with Paul Scofield as Lear. The stage version, also with Scofield, had been produced at Stratford-upon-Avon in 1962.

Question: I found your film version of *King Lear* very terrifying and pure, not simplistic, but kind of distilled to an essence. I'm just curious where that started out. Did it start out with the fishbowls and ferns, or was it initially what you intended? What was the process of getting it to where it ended up?

PB: There is a difficult balance to be found all the time between what is realistic and what needn't be realistic. An extraordinary thing about theatre is that the imagination of the audience is so ready to go along with something that it will respond to any suggestion. But if what you put on the stage is purely in the world of the imagination, rapidly you find it something that isn't rooted in reality; you find that one way or the other there have to be certain natural elements that give a basis to what you're doing. For instance, in our theatre, we've put earth on the floor, because one needed to feel that this was taking place not on an abstract floor, but that what the people were standing on was real in every sense of

the word. Yet, if because of that you then go farther and build an operatic realism, then the realism has turned against itself and is no longer appealing to the imagination.

The most perfect image of this is in the Japanese marionettes, the bunraku, where the actions are incredibly realistic—the marionettes are picking up little books, drinking sake, sewing, doing all the little gestures of life, and yet around them you see black-hooded people, visibly manipulating them. There is no attempt at illusion. I think this is always a balance one has to find.

Now, to go back to *King Lear*. When I did it in the theatre, in the theatre it seemed to me that the play demanded great freedom, and a minimum of elements. Yet an empty stage, with nothing, would not give the support to make you feel that this is a real story about real people. So, by trial and error, I made a set where there was sort of a gray-white surround, and within it elements made out of rusty iron that we left for

weeks to go rusty in the rain. These simple elements in rusty iron had such a strong texture. All of the costumes were made out of leather, so that you felt this world of people riding and living in iron. The leather and iron gave something real, yet the image was extremely bare so that you had an impression of space, of endless space, which was purely theatrical because it was a space of the imagination. The two went together.

Now, transfer that to the cinema. Cinema one can't do in the same way obviously because the marvel, the greatness, of photography, is that it is actually showing you a picture that you can believe in. If we just had a white cyclorama and an actor in front of it, the film would be just a television film of a stage production. Looking at the image, you would just see a man in front of a cyclorama; you wouldn't see King Lear in a story. So, we decided to go on vacation and look for the most barren location we could find, and there's nowhere in England that is as barren as what we found in the north of

Denmark. Then Georges Wakhevitch built a castle, and we carefully looked for elements that would have no association with any period at all, except to allow the imagination to think, "This is a remote period." For example, we took the most primitive simple form of a plate. It looks completely convincing, but hasn't got a design, hasn't got a style, hasn't got a form. We took a knife and a fork in the same way, a chair in the same way.

The visual language was what was indispensable for telling the story: castle, interior, fire, horses, leather, heat, out of doors, opposite, cold, and vast white sky. And then the costumes presented a new problem. The designer, Adele Änggård, had worked on the original costumes in the theatre. She started again, and we saw that in a film the stage costumes just looked stage-y. And again, we wanted it to be convincingly some-where in the mythical past and yet not have a period. It's partly Elizabethan, partly pre-Christian. There isn't a clear period, and there never was a King Lear. We thought, "Now,

where can we find the costumes?" We looked at medieval costumes. We looked through all the books and paintings and references we could, and then, because we were working in Denmark, we found an unexpected solution. In extreme cold, people's costumes haven't changed for two thousand years, for the same simple reason that much of Arabic costumes, dictated by the heat of the desert, haven't changed. So, we had the answer, which was to start with fur and build all the costumes on Lapland and Eskimo models, which are not aesthetic at all, but purely functional: to keep off the cold. Every single detail came out of that need, and what we in fact needed when we were filming in twenty degrees below in the middle of winter in Jutland. Everybody was delighted with their costumes, the only time I ever heard that. And I dressed like the others, because it was the warmest costume there was.

In the following response, Brook refers to two designers. Sally Jacobs's work with Brook included MARAT/SADE and A MIDSUMMER NIGHT'S DREAM; Chloé Obolensky's work included THE MAHABHARATA, THE CHERRY ORCHARD, and IMPRESSIONS DE PELLÉAS.

Question: It would be helpful to me, as a designer, to know if there are certain designers you enjoy working with.

PB: There is only one moment of truth to which you can refer anything: the moment of performance. It's very important to see this, because, in the opera world for the last hundred years, and very often in the ballet world, it's been considered that a designer's work and a composer's work can stand on their own. You go and see an exhibition of designs. What does it mean to see an exhibition of designs? What does it mean that today you can see Picasso's designs for *The Three Cornered Hat*? That you can see the great Chagall paintings that were put on the stage behind either a ballet or an opera? It means that the design stands on its own feet outside the performance. I'm talking at the moment about a different standard: moment for moment what is happening during the performance. You see the great difference. The designer who is interested, to a certain degree, in that, but who really wants his pictures to stand out as designed pictures, is very different

than the designer who wants to be, like the good cameraman in a movie, working shot by shot.

Today, for instance, the designers I work with, mainly Chloé Obolensky, with whom I've been working for a number of years, and before that Sally Jacobs, are both designers who will sit at every rehearsal and will let the design evolve at the latest possible moment. The good designer has all the possibilities waiting, but is working that way, watching, walking around. In *The Mahabharata,* the basis of the physical production, that sort of skeleton that gives you every possibility that I was talking about earlier, in the end became the fact that we had a river at the back and a pool in the front. And all the action, the physical action of the production, was governed by the fact that you could go *there* for a river, you could come *here* for a pond. It was the basis of, I should think, about a hundred moments in the performance. That evolved after two months of rehearsal, but Chloé from the start had a feeling that we must have water. But how and where? We thought of the

water coming all the way round, and then, "No, we don't want to separate the audience from the action," but the idea of water all the way round left a trace which made it possible to think of that little pool there. I would say today that the evolution with a designer, and that sort of close exchange, is the most important thing.

One bad experience was with a designer I worked with many times, and with whom I got on very well. We both liked one another's ideas very much. We had such a marvelous time together, working, and talking, and playing with models and things, that both of us weakened the stand of the other. In a collaboration, you need totally different points of view, rubbing together to produce a result. If you're in mutual admiration, it's dangerous. I found this also when I was designing by myself. Designing by myself, I had the anguish of saying, "This is going to be terrible," looking at it again, saying, "Maybe I made the most terrible mistake, this may be completely wrong," coming back to it, etc. This is very helpful. If you are

working with someone who says, "Oh, that's marvelous," you're a bit reassured, then he suggests something and you say to him, "Oh, that's great." He's reassured, and together you soften the healthy side of anguish.

The other side of this, which is more subtle, is when two people are working together and their ideas do not develop at the same tempo. I like to probe, work, look at something, and then say, "Well, I'm not sure. Leave it till tomorrow, and if tomorrow it isn't clear, we'll wait again, so that something evolves." I was working with a designer, a very brilliant designer, who had what you would call a "Polaroid" mind. You would say something to him, and the complete, detailed solution would come out just like that; that was his tempo. He did great designs in many, many different situations. This was a designer who worked enormously in all parts of the world; he could design an architecture by telephone. I've seen him do it. I mean, he would just say, "You've got a problem. Oh, that's all right, because now you build three feet, then out of that measure two." The Polaroid

in his mind was so crystal clear. Now, compare the difference between developing an enlargement, and a Polaroid. You see there's a difference of tempo. With a Polaroid, in a few seconds the whole thing's there; with an enlargement, a bit emerges here, a bit emerges there, and then slowly the picture comes. It's very important for the director and designer to get to the same tempo, where you are seeing something, you are going towards it, you pull back, you go forward—as with actors—in a shared tempo. If you find that the tempos are totally antagonistic, it can prevent you from working well.

Question: How do ideas get introduced, and how do you work through them together? I think conflict is a very positive part of the process, but when does it become not a positive thing, but a frustration, or possibly paralysis?

PB: If it's for the ego, it's a destructive conflict; if it's for something of quality, you're together. It's very clear. Take the simplest case. You hear constantly: "Who is more important?

The director, the actor, the designer, the author?" The moment the question is put in that way, it's a stupid conflict, because it's a conflict between egos, each one of whom wants to be the most important. The moment you turn it the other way round and say, "We want to do something of quality, this is so difficult that none of us can do it alone," then the argument, the opposition, comes into a different perspective. Now, the hierarchy question is a very difficult one, because there's destructive hierarchy and creative hierarchy. On the one hand, hierarchy that's fascistic, that's based on corporate structures where people have to be in positions of impor-tance, is everything that one dreads in the word "hierarchy." On the other hand, if you know somebody who has to have a very dangerous operation, like the separation of twins, and it's being done by a team of surgeons, you respect immediately the fact that there has to be an absolute order and structure: the head surgeon, the second surgeon, the third surgeon, the nurses, the assistants. Nobody in a life and death situation like that would stop the process to discuss their individual status

need, because you are in something that clarifies that; it is a necessity.

A director, when he is drawn towards a piece of material, has something more than just the ordinary decision. He has something which is as impossible to define as a hunch or a taste. He takes a great script, and he has no idea, I mean, "Oh, I want to do this in modern dress," or whatever. He just has a smell of where he wants to go. I've found that that is absolutely necessary to have a good result. If that's not there, then you argue, you talk, you discuss, but if you have it, then that becomes the leader in the hierarchy. However open you are to the collaboration of a designer, however open you are to the collaboration of the actors, you are all the time not saying, "We're so democratic that we could go there, or we could go there"; you're saying that "somewhere over there is what we're looking for." That means that the director is the final initiator of the direction. If the relationships between him and the others are good, then everyone is willingly going along with

this. It can also work just the other way around. There are cases when the strong hunch comes from the designer, and the director can be open and very grateful for that. There, again, is the hierarchy, but the hierarchy is guided by the *designer's* hunch. That's only possible if the designer's hunch is deeply related to bringing out the quality of the material, and so far from wanting to make design for its own sake. Everyone respects it, and the director is more than grateful. The greatest designer of this sort that I ever knew was Christian Bérard, in France. At a time when there were thousands of talented Frenchmen, all with taste, with a feeling for costume, marvelous schools of painting, there was this one unique, extraordinary, touching, shambling, naive figure like a big bearded bear, whom everyone adored and called "bébé." He would refuse offers because he was so humble with himself that he would say, "I can't do it. I don't know how to do it. No, I can't possibly." And out of that would suddenly come a flash, and [Louis] Jouvet, whom he worked with most of all, who was a very fine director, would find his production out of that flash

when Bérard would suddenly see, like that, a taste, a line, an arc, and his best designs were just something like that on a little bit of paper, or on the palm of his hand. The director would look and say, "Ah! Yes!" and then they could go forward together. So, it can come either way.

Question: Something that strikes me in your movies and your books is the integration of the actor's physical life into the visual landscape that you've created for him. I was wondering if you could talk about the process you go through to maximize both the designer aiding the actor and the actor understanding the possibilities within what the designer has set up.

PB: I think that the designer must bring a very positive contribution of his own, but he must start by recognizing and respecting that the costume, for example, is the actor's tool, and that the actor starts with something very, very tiny in himself. At first, he's very protective about it because it's also a formless hunch which he's letting grow. He will often talk

very quietly at rehearsals because he isn't ready to talk, to shout, to talk loudly, then gradually the actor begins to realize that he has to communicate and share what he's doing, and what he has secretly begun to find is able to go outwards.

For it to go outwards, there comes a point where the costume becomes one of his biggest tools for projecting outwards to the audience. If the designer is in tune with him, then when he gets out of his rehearsal clothes, and puts on the costume, he feels better. If the designer isn't in tune with him, he can feel either not helped, or, in a lot of cases, truly blocked. The old myth—it was better in rehearsal than it ever was onstage—which should never be true, is true, because the design has not gone along with him. One way or the other, there has to be a very, very sympathetic understanding and relationship. Designers, once they've got set on what they want a costume to look like, can be brutally destructive and impatient with an actor. The designer who wants the person to have the silhouette that corresponds to a period, whose

aesthetic idea can be very right, can be in contradiction to the actor's need for a certain freedom. In precise technical things like that, someone has to give way, and there I think in the end the actor *has* to be served. He *must* feel confident and free in his clothes. That is the process. Does that correspond to what you ... ?

Response: Well, I guess I was wondering how you find a bridge so that actors not only live within the space, but maximize it and use it to support themselves.

PB: It's a difficult question. What's difficult is that everyone, the director, the designer, and the actor, have to have a certain flair that is there, yet can't be explained, and can't be transmitted. It's like a musician; there has to be a certain feeling. God knows where it comes from, or perhaps God *knows* where it comes from, but it has to be there. It can be developed, but I think it develops most of all if you can recognize the value of experimenting within the process. For instance,

to use space well, the more you can encourage actors by many, many different means to *explore* the space, the more you'll go beyond your own ideas, and the more the feeling that—are you a director or designer?

Response: Both.

PB: If you once, in an early rehearsal, give an actor a feeling that it's out of turn for him to try something, or propose something, because there's a question of authority, and if you once push him down, there's no going back on it. If, on the other hand, you can make him feel that if you said, "Sit in the chair there," you welcome the fact that he then gets up from that chair and goes over to the other one; if he feels that that's welcomed but not necessarily accepted, the space will be explored.

Do you know [Henri] Cartier-Bresson's photographs? Do any of you know this French photographer? He is one of the great photographers of our time, but he denies that there is any

aesthetic which should come into photography. For him, photography is an extraordinary sense of being so ready to capture the exact moment, that if one person is doing something, and at that same moment someone else is doing something else, and he's ready, he'll capture a picture in which you'll see something that is uncanny—seventeen people in a street who are all just for one moment in eternity looking here, looking there, looking there, and looking there, in a way that makes a composite relationship. That's totally different from the photographer who has an aesthetic idea and arranges his composition to make a good picture. The reason I'm saying this is that I've found, and this is the same in the cinema or in the theatre, that by work you can get people to find the exact physical relationship that corresponds to what's happening at the moment. If, for instance, we're sitting and we're talking at the first rehearsal, we do it like this, but once we've experimented and our sense of the meaning of the scene has grown, there comes a point when I can get up and you can get up and we see the table and I've

come to there and you've come to there and there will be a moment when we find that the distance, the relative height— one is sitting, one is standing—the fact that someone else is there, suddenly make sense. Not for any artistic reason, but because this is the essence of the human relationship. You could suddenly draw two lines, and say, "Ah, if I look at those two lines I see why those two people are there." Then the distances and the positioning and the relationship of the furniture is suddenly right. I've found this for instance with crowd scenes; I've found it in a movie, with developing a shot. If the relationships are right, it looks right from any angle.

It's a fascinating thing that for a long time one tries to apply ideas of what is a good composition. I can go right back to my very first productions. I really remember going on the stage during rehearsal and saying to someone, "Just stand there, and will you put your hand there, yes, thank you," and the actor saying, "Um, is this all right for your picture?" At the time, I

thought, "My picture. Yes, why not?" Then over the years, I thought, "But we're not making pictures. What are we making? We're making relationships." But we can't *make* relationships; we can *let* relationships, because that's what any story, any play of any description, anything human, is about: relationships. In scratching away to find the bedrock of that, you're doing something like a painter or sculptor who is eliminating what's not necessary until the shape is there. That shape then becomes aesthetically pleasing, and I think that is what touches you. You see, it's inhabiting the space, but not for "artistic" reasons.

Question: Did you find a time when you stopped choreographing pictures and yet still kept your concern about how beautiful the stage looks? I'm saying this badly, but …

PB: No, I see what you mean. Yes, I think I fairly rapidly stopped doing choreography, yet still wanted to nudge it in the direction of making good pictures. Then there came a time, I'd say, when I really got out of the proscenium theatre,

when I ceased to care at all about that. I'd say that today I don't care at all, and that's not quite true, because I recognize that if something looks ugly or clumsy, it's defeating the intention. So, in fact, the circle comes round to the same point: in the end you want it to look right, and looking right, one step farther, is also looking beautiful.

I think that one can't work in the theatre without recognizing that it's very healthy for there to be influences. A big company comes for the first time to London, and shows what it's doing, and six months later everyone's copying it. That's how it should be. Some things are badly copied; some things are useless. I remember Martha Graham coming to London. I remember going to the Sadler's Wells Theatre, and there were about twenty people in the audience, about half of whom walked out. The critics were terrible. And six months later, every choreographer in the country was imitating everything because they were the ones who'd stayed. And then when she came next time, there were a few more

people, and then, suddenly, you can't get into her shows. The same way with Merce Cunningham. These influences are very important and very powerful, but they mustn't last. Today, if you tried to do a Brecht production, copying what Brecht was doing with his model books, it would be out of date. It won't work the same way. It worked for a very short time, just within Germany, just within his milieu. By the time it reached England and France, people had started copying the externals of Brecht, totally misunderstanding what he himself brought into his work. He was a tremendous theatre man, and his productions had a richness of vitality and beauty and emotion that he didn't allow in his writing, in his descriptions of what he was doing. By the time his model book was used as a basis for their work by directors who were so committed to these ideas that they did sterile, bloodless, and formal versions of the plays, the heart had gone out of the ideas. No style should last too long.

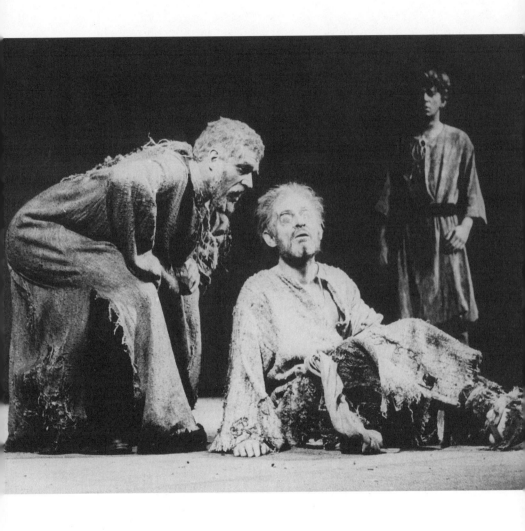

IV.
Film

Gerald Feil, Brook's cinematographer, co—film editor, and associate producer on LORD OF THE FLIES, had brought a new and enhanced print of the film to Dallas, a print prepared for the film's impending commercial release on videotape. It was this version which was shown.

Contrary to our expectation, this section is brief. Brook turned the question and answer session into a lively discussion between members of the audience, thereby minimizing his own participation.

In discussions about LORD OF THE FLIES, he several times spoke of a need to follow through with the children from the film, to learn how the filming had affected their lives and development. He seemed preoccupied with responsibility for the degree to which the intensity and

nature of the roles in which they had been cast as children might have affected them subsequently. During a recent trip to London, I was able to see a BBC broadcast documenting his return to the island on which the film was shot, with the now adult men who had played the film's five major boys' roles. He had succeeded, after thirty-five years, in following through. It is an unusual and engrossing document— moving, unexpected, sentimental, and, for me, occasionally very painful to watch in the candor of its individual and personal searches.

At one point after the Dallas screening of the film, the discussion veered into a concern with "manipulating the perception of art," e.g., viewing a sculpture from a photograph, rather than from first-hand perception. Questions of directorial "manipulation" were also raised. Brook became somewhat acerbic in his response.

PB: [In response to a discussion of "manipulating the perception of art."] What I don't understand is why today one is still prisoner of the phrase: "manipulation." It's simply that this has become a phrase which like "fascist," "sexist," and so on, can be used to arouse emotional responses without anyone thinking really what you mean by it. Of course, at this moment in talking to you, I'm trying to use words that are convincing and I'm manipulating you. Now, if you remain sitting here and allow yourself to be manipulated, so much the worse for you. Nobody forced you to come and see this film. Every single relationship is a complex series of deals and bargains that one's making, consciously and unconsciously. One has to, I think, be very careful of simplifying a complex relationship with a work. An author is using his words to produce a certain response. There was a time when people would say that by going into a theatre and looking at the stage, the audience was being tricked into believing that they were looking at real life. Only a very simple brain could imagine that sitting in a theatre and

looking at the stage and seeing somebody strangled on the stage is looking at real life, and that if you take away the scenery you're suddenly no longer being manipulated. Brecht believed that if you have a big slogan hung up in the air which says, "This is theatre," you're being less manipulated than if there's a realistic piece of scenery. These are all different forms of the endless strategies that life is playing, and when one enters into the game of life, which is when you leave innocence and go into experience, you just have to keep your eyes open and decide whether you are interested in the film. Of course it has a point of view. That point of view, you know quite well, comes from somebody invisible who has made that film. It is a selection; there is a choice involved and that can be assessed from many, many points of view. But I wouldn't have thought that the question of manipulation really comes into it.

Question: Could you comment on your process in adapting *King Lear*? I know you manipulated the lines,

between characters even, and I felt it was wonderfully justified because it opened up the play for me. I know purists don't like that, but is there an instance in which you would film a Shakespearean play word for word all the way through?

PB: No. A particular play of Shakespeare is written for the words to unroll from the first word to the last, almost nonstop. A film is made for the separate images to unroll, almost without a stop. If, in a film, you put in a fade to black, and then you leave too much time before you fade back in again, the film just drops completely. It's quite extraordinary how very little time you dare put between one shot and another. If you really put between each shot just that much of black film, nobody would follow the story anymore. So, from the moment the reel starts rolling, a film has to go nonstop, that constant flow is a flow of picture. In a silent film, you can be held from beginning to end without one word of dialogue; there are many talkies with minimum dialogue. This is the case in *Lord of the Flies*.

Somebody commented on the fact that there isn't a lot that's spoken. The words that are spoken don't have to link together; the linking is the flow of images.

In a play of Shakespeare in the theatre, the linking is the flow of words, which is why, if a production has too many scene changes, it becomes boring. Shakespeare, done in such a way that you can change from one place to another and keep the flow of words going, means that the play is kept alive and off the ground. So, the transition is very, very delicate. It's very difficult moving from one form to the other. In theatre, you have to take something where the lifeline is words, words, words. In a film, you try to observe if there are too many words for the flow of images, and you have to find a way of dealing with that. It's a very, very interesting and very, very tricky question. If you have too few words you lose perhaps the guts of Shakespeare; if you have too many words, you're bogged down. You have to find a new way of dancing between the two.

Question: Between a movie and a live theatrical performance, which do you think an audience is more affected by, and why? And if you could choose, which do you enjoy working on more?

PB: I enjoy working on a play more, and seeing a movie more.

Question: Why?

PB: Why. Because when you make a movie there is a thing which is, if you've experience of the theatre, very difficult to stomach. Movie making is slow and often very boring, because you have to wait for no good reason for something that is of no interest to anyone, the weather, or waiting for somebody to come and repair a broken generator. What interest can you have in a day when you're all keyed-up to do something, and are sitting on boxes, waiting? Movie making has that against it. Once it's finished, on the other

hand, this tight and constantly moving image is very exciting to be with.

Theatre, it's just the other way round. When you're working with a group of people, every minute of every day there is a flow and a rhythm and if it's good work everybody's caught up in that. And so your days are fully charged. Maybe the result, when it comes in front of an audience, isn't nearly as exciting. I find very rarely that going to the theatre is exciting, because it's very difficult. At their best, both are equally compelling, but not in the same way. Obviously. Filmgoing is a lonely experience and a solitary experience. You're just as well off being alone in a screening room as surrounded with a group of people, because the power of the big image is so enormous that it really saturates almost all the circuits of the brain. It really does go right into your head, and you haven't much left with which to be aware of, or even interested in, the people around you. You're right in with all that invading image and, if it's good, it's a very strong experience.

Theatre, it's quite the other way round; your experience gets better and better if all the people around are in it. And for that to happen, something very, very good has to be happening on stage. Which is why perhaps one can be more interested by an ordinary film than an ordinary thing happening in the theatre. I find something ordinary in the theatre extremely uninteresting because I don't think the form of theatre is interesting just by itself. What is it? It's a stage and some bits and pieces, while the form of cinema is compelling because if you just have a screen and somebody moves rapidly across it, you can't fail to watch. I think that really goes back to why Westerns are so interesting, and have always been, from the beginning of cinema. Just that shot of a horse galloping. That's why "movies" is a very good word. Movies really mean that it's interesting because it moves. In the theatre, you have to *be* moved, and that's much more difficult.

A number of Brook's films, in addition to LORD OF THE FLIES (1963), have been issued on videotape: THE BEGGAR'S OPERA (1953/with Laurence Olivier), MARAT/SADE (1967), KING LEAR (1969), MEETINGS WITH REMARKABLE MEN (1978), THE TRAGEDY OF CARMEN (1982), and THE MAHABHARATA (1989/in both complete and shortened versions). Not all of them remain currently available.

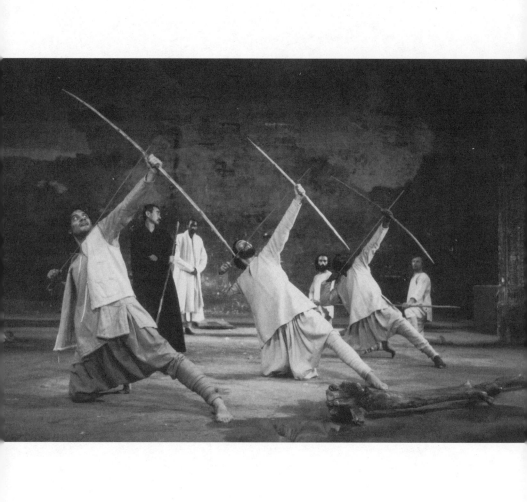

V.

Multiculturalism

The Mahabharata (1985)
"*Mahabharata* is an extraordinarily dense, complex work, which on one level deals
with the psychological misunderstandings that there can be anywhere on the inside
of any family. On another level, it deals with the essence of politics, with what leads
to factions, to strife, to conflict. On an even larger level, it is about what war is
made of, and on a still wider level, the actual meaning of conflict, not in society,
but in humanity and, you can even say, in cosmic existence." (p. 146)
Photo by: Gilles Abegg

Multiculturalism, *a recurrent concern in Brook's remarks, was also frequently the subject of questions addressed to him. The theme warrants a section of its own, but it is often difficult to separate from other concerns of which it was a part.*

The moderator of a panel loosely entitled SHAKESPEARE, POLITICAL THEATRE, AND CROSS-CULTURAL THEATRE perhaps unwittingly set the stage for a special demonstration of Brook's intellectual acuity and virtuosity. Deviating from the standard question and response format, the moderator asked each member of a three-member panel to formulate a question of personal interest at the beginning of the session. She then solicited additional, unrelated, questions from audience members. Confronted simultaneously with five disparate questions, Brook began to speak. It was quickly evident that he intended to answer all five questions within a single response. His answer and synthesis follow.

The allusion to MEETINGS WITH REMARKABLE MEN *is to Brook's 1979 film. G. I. Gurdjieff (1866?–1949) was a philosopher and spiritual teacher. Although they share a title, Brook has written in* THE SHIFTING POINT *that his film "is quite different in structure from George Gurdjieff's book." Brook's very personal and intense relationship with Gurdjieff's teachings is documented throughout* THREADS OF TIME.*

The "God's spies" reference is to KING LEAR, V, 3, 16–17. *"Time with a gift of tears" is from the Chorus ("Before the beginning of years"),* ATALANTA IN CALADON *(1865), by A. G. Swinburne.*

And although the final question is from an earlier session, it is difficult to imagine a more appropriate or satisfying summary statement than the answer it elicited.

Question: How has the international collaborative effort traveled into your most recent major work? That is, have you retained the international sense of collaborative event, have you reduced or expanded it, or altered it in some configuration that is meaningful to the questions that you are asking yourself artistically now?

Question: You've done two productions of *The Tempest,* one the earlier Gielgud production in Stratford, and the other the more recent production with your international cast. In what way did the play change for you; in what way did it become a different play?

Question: I am very curious about *Meetings with Remarkable Men*—whether you were telling me a fairy tale to give me some truth, or whether you thought there really was a Shangri-La, and how that might have affected the work you've done.

Question: I wonder if you could tell us more about the meaning of real multiculturalism and what it signifies for you?

Question: I'm always slightly puzzled by the term political theatre, it seems to me that all theatre is inherently political. What is nonpolitical theatre?

PB: It's very good to have such a difficult series of questions because it makes us, compels us, to go straight to the root. The root, obviously, is that at the basis of anything we can talk about, there's life. This is obvious to all of us. Life is inevitable. Gradually, life takes forms, whether this is in the life of a baby growing up, or the life of a society, or a cycle of history, from something without form. Gradually life takes forms that become more and more varied, more and more complex.

When one speaks of culture, culture isn't the last word. We're not all simply defined by our culture; this is already secondary.

I think that if one doesn't accept that, all the rest becomes totally confused. If one believes that a person's identity, a person's definition, and consequently a person's reality, is his culture, then one's denying something much more important. The living person is a living person; this is what the entire humanity has in common. From that ground, cultural differences slowly develop and become more and more and more pronounced, and eventually become highly sharpened by every form of the inevitable conflict. The conflict makes even clearer the different definitions that each person has. These are processes that don't belong to us, and which one can't deny, one can't change; this is how the world is, and our only concern, our only interest, is to understand these processes.

The world is, by nature, a complicated place; life is a complicated process, which, at the very root, is extraordinarily simple. So what we're talking about this afternoon, and what links all these questions, is that development. Because in the theatre everything is more concentrated and consequently can

be seen more clearly, the middle area that for us is normally so confused can be illuminated, literally illuminated—just like, because we're sitting in a small space now, we are illuminated because a whole lot of eyes are directed on four people, and we can be seen more clearly than if we were all mingling together as we were last night in a big crowd in the corridor.

When we first began to work with actors from many different parts of the world, the purpose was not for the principle of being intercultural. That's just a slogan; that's just a way of talking. "Let's be intercultural, let's be interracial." There is something too racial and too cultural in even talking about being interracial and intercultural. That is not what it's about.

What it's about is something again much simpler: that any human being is incomplete. Any human being consequently has something he desperately needs from another human being. And what he needs from another human being is not only that deep feeling of fellowship which brings people

143

together, but also the sense that what the other person has can develop and complement what *I* can bring. That's what's most important in any bringing together. At the very beginning of our work in the international center, the very first play that we did together was a Grimm's fairy story called *The Five Servants,* that we did one Christmas for children. It is about a hero who sets out to rescue some heroine who's been, I forget, abducted or is in trouble at the other end of the world. He isn't strong enough for this incredibly difficult task, and on the way he picks up five people. The five people, I am not remembering in detail, but it was roughly that one has extraordinarily clear sight and can see tiny events three miles away, another one has extraordinary hearing and can hear a pin drop at the other end of the world, another one has the capacity to drink a whole lake of water and so he could cross the barrier of a lake that no one else could cross, and another one has the extraordinary capacity of being very hot or being very cold whenever he wants, and that enables him to go warmly through an ice floe and be cool under a blazing sun.

Together they make a group, and because of this they can go through all the tests and challenges. This very simple story is really what an international group is about.

People from one culture have bodies that from childhood and from tradition are better developed than anything we can develop. There are cultures where perhaps a thousand years has led to a different relationship between what goes on in the mind and what goes on in the feelings. There's a whole Western culture that is dominated by its capacity to reason, analyze, and argue. When there are a lot of us together, it is the worst possible thing, but for people who have not had this particular formation in the twentieth century, this is of great value. It is like having the capacity to be hot and cold or to drink a lake. The basis of the international group was, and still is, the fact that each member, however much he sometimes gets impatient with the other person, recognizes that he is working with someone who can bring something that he can't bring himself, and that the two together make a richer field

not only of skill, but a richer field of possible understanding. When a group has this possibility, the group can feel and understand a theme more deeply than anyone can by himself.

Mahabharata is an extraordinarily dense, complex work, which on one level deals with the psychological misunderstandings that there can be anywhere on the inside of any family. On another level, it deals with the essence of politics, with what leads to factions, to strife, to conflict. On an even larger level, it is about what war is made of, and on a still wider level, the actual meaning of conflict, not in society, but in humanity and, you can even say, in cosmic existence. What is the meaning of conflict? Is it totally negative? Has it a positive meaning? How can it be inserted into an understanding of the whole cycle of human creation? Now, this is vast. To go from the little psychological thing of a person being jealous of someone else, to the whole cycle of creation and destruction, this is all in *The Mahabharata*. While each one of those themes found its form in a Hindu culture in India, at a certain moment in history,

you can see just at this very moment in talking about them that not one of those themes belongs to a culture. Does the theme of the creation and the destruction of the universe belong to a culture? Does that belong to a period of history? Does it concern anybody more or less than anyone else? Does the theme of hatred within one family belong more to one culture or to one period of history? No. What belongs to one culture and one period of history is the story—the way that those great themes are turned into a story, like the story of the young man going out to save the girl and having to find five people to help him. That's the form that the story takes so that these cease to be abstract ideas and come right into the world, becoming real. And because they come right into the world and become real, in that sense they can be acted. They can be told to other people through human bodies in motion. Which is what acting, after all, amounts to.

So, what was important for us with this theme and an inter-national group was exactly the same in *The Mahabharata* as it

was in *The Tempest*. The group was composed of individuals, from, in the end, I suppose about twenty countries. Each one felt this was his own story. But as we began to work, each one could enrich the understanding of the other. While none of us alone could go from private jealousy to universal themes touching the whole of humanity, together it was possible to feel and enter into the whole kaleidoscope of the story in a way that was looked at and exchanged and shared from many points of view—points of view which were not so much intellectual points of view, but rather the living points of view of people working together on a scene and evolving it together, which is a process in which points of view are all the time being exchanged. What came into existence wasn't any one person's point of view, not more the author nor the director nor any one of the actors, but a collective cake. When it was put in front of an audience in a theatre, it was to be shared in a living way and developed with those audiences. And with this, we played in Los Angeles, we played in New York, we played in Australia, we played in Denmark, we played in Scotland, we played in

Japan, and in a way there was no mystery. This Indian/Hindu story, in each one of these places, had a different response in detail. Obviously, a Japanese audience reacted differently in detail to a Scottish audience. But not essentially, because, in the same way, the Scottish audience was thrown back to its mythology, which is a Nordic mythology, and is, it is widely believed, linked to Indian mythology. More essentially, the roots in human experience are there, so the tough person of Glasgow, with a sort of street-wise intelligence, suddenly finds himself sitting there amused on the street level by a story that could be happening today, and yet is touched by something that takes him right back to his Celtic and Nordic intuitions and mythology. This joins to something coming out of India, and joins straight through to the Japanese, who, physically, responded quite differently. The Scots laughed and reacted and then became silent, and the Japanese sat motionless for nine hours, except at the very end, during the battle, when we thought they weren't moving at all, one noticed tears, streaming down their cheeks at this tale of destruction.

That's culture. These are outward ways of expressing some-
thing. As you come down the pyramid, all these superficial
differences disappear and the experience is the same because
it is coming from the same source. In the same way, Shake-
speare wrote a play called *The Tempest*. I think it is completely
unimportant who Shakespeare was. I mean, one can write
books about it, one can prove or disprove, and it gives lots of
people a full life's work for which they're well paid, and
so thank God for anybody who's not unemployed today.
There are Shakespeareans who have proved that the fif-
teenth Earl of Norfolk had a cousin who really wrote
Shakespeare, and cheated it under the doormat of Eliza-
beth's palace. The fact that such theories exist is valuable
because it gives another generation the work of disproving
it, and so these works on Shakespeare go on forever. But
from our point of view, who he was is of no importance
whatsoever. What his personal views were is not important
because we cannot really prove them; it's a matter of taste
and opinion. All we know is that a series of works exist, and

they are here today because over the centuries they haven't fallen by the way.

There's never been such a period of super-production in England, in English theatre, as there was in Elizabethan times. Something like twenty-five thousand scripts were written. There's no conspiracy theory that can explain why twenty-five thousand plays were pushed to one side and Shakespeare, because he had some important friends, had his plays pushed forward in a conspiracy which could have lasted until today. So, it's simpler to say that there is a virtue in those scripts.

If there's a virtue in those scripts, it's because for rather mysterious reasons, in writing, it's possible to write at a level where although the words never change, the possibilities that they evoke are inexhaustible. It is a mystery. There's mystery between writing a closed phrase, which has one meaning only, or an open phrase which has an infinity of meanings. Take, in Shakespeare: "and talk about the mystery of things as

if we were God's spies." Now, take that sentence, and take just what the words contain. Talk about the mystery. Mystery of what? Something very simple. Mystery of things. What's that? The mystery of things, but in what way? As if we were God's spies. One tries to understand that. One tries to imagine that one takes a sheet of paper and one draws lines coming out of each one of those words and sees what associations they bring, how they intersect; you actually can reach, from that simple sentence, something almost as complex as the whole *Mahabharata*. Just out of that, really ponder on what the mystery of things could be, and then just take the juxtaposition with "God's spies," and you can see that, yet again, one can give employment to all the unemployed writing books to try to interpret it. But no one can express the last word. I mean, it's only a pretentious fool who'll say, "I can explain once and for all what that means." It means that its greatness is linked to its inexhaustible openness. Now, you can contrast this. I was thinking not long ago of a phrase. Let's see if I can remember it. It's from, I don't know, perhaps one of you

know, from some eminent Victorian poet like Swinburne or Coventry Patmore. I don't know which, but it goes, "Time with a gift of tears, grief with a glass that ran." You look as though you know …

Response: It's Swinburne.

PB: Swinburne. Now, just take out that which sounds melodic and poetic and very nice, and see what it contains. "Time with a gift of tears" sounds very pretty. What is there to ponder over? "Time with a gift of tears." In other words, a fairly simple, vague meaning, and now grief has an overflowing glass. "Time with a gift of tears, grief with a glass that ran." I don't think that one could solve the unemployment problem with those two lines because there is not, if you just put them side by side, that which really provokes one to enter into the depth of one's own capacity to think and feel and ponder, and then to see how with other people together we can enlarge and enrich the thought. How rapidly you would find that

you've teased out of this pretty phrase of Swinburne almost all its possibilities. One sees the difference between two things which in general categorize our poetic writing. One sees that the difference is more than a million percent; it's two totally different animals. Because of this quality, to come back to the inexhaustible phrase, a play like *The Tempest* is equally an inexhaustible play.

I did one production thirty years ago with professional Royal Shakespeare Company actors, with the great actor John Gielgud in the lead. I had thirty years' less work behind me. And it was a different age. It was in the fifties; it was a totally different moment in world history and English history. We sat there thinking we were doing our own work, but we were, of course, influenced by all the currents of the time, in Stratford, and in England. Thirty years after that, in Paris, after *The Mahabharata,* with an international group, many of whom had been with us from the very beginning of this work, had traveled in the Middle East, had traveled in Africa, and had been

through many, many experiences together, we came to work on *The Tempest*. It was obviously at a different moment in world history; not one single detail of the earlier production could possibly have any connection at all. It couldn't be; something would have been very unhealthy if there had been any similarities at all. The only thing was that the experience of the international group in *The Mahabharata* enabled this group to bring more to a play of Shakespeare than the professional group at Stratford. It wouldn't have been necessarily the case if we'd been doing *Henry IV, Parts I and II,* because *Henry IV,* which is a great play, is rooted in English social history. A British cast has better roots, perhaps, than anyone else, for starting to work on that play, but *The Tempest* takes place nowhere. It has no place either in geography or in time. It's a completely mythological play, and it's about magic.

Now, I have never met a European actor who in himself had not only a belief in, but a concrete experience of, magic. When Shakespeare wrote his play, England was very different,

and he was a man from a country where there were still witches and prophets and all the background going right back to the Celts and the Druids that formed English life. This has now completely vanished in urbanization. On the other hand, for the African actor who played Prospero, every element in the story made natural sense. He had grown up within that tradition. And, he had a completely different meaning to bring to that part, as did the other African actor who worked with him, who played Ariel. They brought a different meaning, not because they were of a different race, because they were of a different, living, tradition. That living tradition informed their work. There's a worn-out cliché that it's interesting to have a black actor play Caliban, because all sorts of slogans can be read off that; at once the play is compartmented into a play about racism and oppression, and therefore the colored actor plays the oppressed slave. That seems to me a destructive, basically shocking, and disgusting way of using races as tokens and as symbols.

The casting also should arise by experiment and trial and error, until one sees what's really in someone's essential nature. This essential nature brings an illumination to the role that someone else cannot bring. And suddenly, when one works in this way, something apparently made of bits from all different sides becomes homogeneous. It becomes one thing, and I think in this case *The Tempest* became neither more nor less Shakespearean; it became a view, an expression for today of that play, that could not have happened in that way without this group of people.

Now, just to complete this long chain, we've gone on from this work to something called *The Man Who, L'Homme Qui,* in Paris, which is entirely about the brain, about neurology, in which there's no decoration. It's not even modern, in the sense of there being anything external to the story itself, other than two television screens because they're necessary at certain places in the action. Otherwise, there are four actors,

all of whom were in *The Tempest,* and the emphasis is on what is happening inside the brain. I think the fact that, again, this tale is not seen naturalistically, through just people of one part of the world, but is seen through a group of actors who play different patients of different ages, who play alternatively doctors and patients, one of whom is African, one of whom is Japanese, one of whom is German, and one of whom is French—and in the English version will be English—quite simply makes the essential side of the story more visible. It carries a greater sense that what is happening in the theatre is about everyone.

So, I think that covers the whole thing, except this gentleman's question about the Gurdjieff teaching. I don't think you'll believe me, but I think I've actually been speaking about your question all the time. In an indirect way. The theatre is always a reflection of reality. In fact, Gurdjieff used this expression. In one of his books he talked about theatre as "the reflector of reality," and that means that whatever hap-

pens in the theatre isn't real; in the best sense of the word, it's an imitation. That's why we can look at it. It isn't the real thing, but an expression of the real thing through a mirror. Anything that happens in the theatre is like a metaphor; it's not the thing itself, but it helps you to understand the thing because the real thing is not this but it's *like* this. Now if it's possible for a group of people, working together, to discover that to work better together you need to develop certain conditions of work, that it is better if you're close to one another, that a force comes out of being in a circle because a circle has a natural force, these are simple practical things you'll discover.

If you don't listen to one another, your work will not have the quality that it'll have if you can learn to listen together. And listening isn't as easy as it sounds. What listening really means, what the act of listening is, is a mystery. But the moment you actually find that these are practical things, and that you can't work without them, that you can't work without being in a

certain condition, that you can't work without a certain con-
centration, that you can't work without listening, and that
you can't work without recognizing that if something appears
it's not because of you, you see that you've become, singly
and together, an open instrument through which something
far beyond you can appear.

When you see this, you see that, in fact, *The Mahabharata,*
which deals with the whole of life, or any other subject which
deals even in a simple way with the whole of life, when
worked upon by actors, is not the same thing as a spiritual
discipline, but a *reflection* of the same things, in an easier form.
In the theatre, we pay very little, and we can go very far. To
make that real in life demands something infinitely more
difficult. Putting this into practice in life is infinitely more
difficult. Theatre can never be a substitute for life, a substitute
for living experience. But it can be a metaphor that can give
one the force to go into life knowing that it's going to be
much more difficult once you get outside.

I'd say that my own conviction is that if the theatre takes a situation of conflict and opens that situation, shows its most negative aspects, and simultaneously evokes in the person watching a very positive feeling, that's political. That person then emerges. I think this is what happened with Greek tragedy, that the whole of the city would come into the theatre, they would see how inevitably terrible certain catastrophes are in life, and they would go back into the city, stronger, to go into the much harder question of living the next day. That I think is what happened in tragedy.

I think that is where one must be careful of political theatre. If you show a true injustice, for instance, we are sitting here comfortably in Dallas at this moment and we do an improvisation showing a sniper killing a child in Bosnia, then there's a great question. Are we awakening amongst ourselves something positive or are we just using our indignation, to make ourselves more negative than we were? And if political theatre is one-sided, however justified the cause, if it doesn't simultaneously

lead to something that is not only active but active in a healthy way, then the political theatre is reproducing the conditions that produce the very thing that that theatre is denouncing. I think that's what one always has to weigh because there are moments when issues are so burning one can't keep silent about them. One has to see, however, the danger of whether the cry of protest is hammering the nail in deeper, or whether the cry of protest is helping to pull the nail out.

Question: Since theatre is such a boundless form, that can include people from all different cultures, and speak political ideals to a large audience, do you feel an obligation or responsibility to speak those political ideas, to include people from different cultures, or is it just something that you personally find gratifying and fulfilling?

PB: I think that what is marvelous is if, for ten seconds even, one can have a taste of a better world. Building a better world may take thousands of lifetimes; we don't know, but it

isn't even worth talking about unless somewhere in one's life one has tasted it. And that's what I think is important in theatre; a theatre experience should bring one to a moment where, even on a very simple level, you see all that's going on in the world, and yet you live the fact that the same people who are killing one another can work together. So that's not a theory. It's a reality, and you see it for ten seconds. If it can happen for ten seconds, then your belief that it's worth struggling for makes sense. But if you don't continually taste that, then it becomes another theory. You know, the whole tragedy of Communism has been that what started as a marvelous ideal ceased to be a living ideal and became a slogan; politician after politician would say, "the better life," "we're working towards a better future," "we're building a new future," and each word lost its meaning. The taste was no longer there and it became words. That's something that is important and gives courage back to people, but what matters is to taste it.

In *April 1998, Brook opened a new production at the Bouffes du Nord. Written with Marie-Hélène Estienne, JE SUIS UN PHÉNOMÈNE (I'M A PHENOMENON) explores the unique abilities of Solomon Shereshevsky, a celebrated Soviet mnemonist who died in 1967. The LONDON TIMES described the new play as, in many respects, a companion piece to THE MAN WHO, finding in it a thematic implication "that the brain remains unknowable and exists in relation to yet more imponderable issues to do with friendship, God and death." As of this writing, the production is scheduled to tour in Europe.*

In light of the preceding pages, I am arrested by the last line of a second review (SUNDAY TIMES):

> *Like so many of Brook's creations, this play, too, ends on a question mark that has the solidity and richness of an answer.*

Appendix

1965 *Marat/Sade.* (RSC/New York.)

1966 *US.* (RSC/London.)

1969 *King Lear.* (Film.)

1970 *A Midsummer Night's Dream.* (RSC/Stratford-
 upon-Avon.) Brook's move to Paris. Centre
 International de Créations Théâtrales established.

1972 *A Midsummer Night's Dream.* (World Tour.)
 Brook's travels through Africa with experimental
 "carpet shows."

1974 Bouffes du Nord reopened.

1975 *The Ik.* (Bouffes du Nord.)

1978 *Meetings with Remarkable Men.* (Film.)

1985 *The Mahabharata.* (Bouffes du Nord/Avignon.)

1987 *The Mahabharata.* (World Tour.)

1988 *The Cherry Orchard*. (Brooklyn Academy of
 Music, New York.)

1989 *The Mahabharata*. (Film.)

1990/91 *The Tempest*. (Bouffes du Nord and elsewhere.)

1992 *Impressions de Pelléas*. (Bouffes du Nord.)

1993 *L'Homme Qui*. (Bouffes du Nord.)

1998 *Je suis un phénomène*. (Bouffes du Nord.)

Brief Biography of Peter Brook

Peter Stephen Paul Brook was born in London on March 21, 1925. His Russian parents had escaped to London just ahead of the German invasion of Belgium, where both had been students at the University of Liège. His father held a degree in electrical engineering, his mother a degree in chemistry. He grew up in England and Switzerland, attending schools in both countries. (Brook speaks several languages, including French and German.)

At sixteen, he left school to work for a company producing commercial and industrial films in suburban London. A year later, 1942, he began studies at Magdalen College, Oxford; he received his degree in English literature and foreign languages in 1945.

While at Magdalen he also founded the Oxford University Film Society, and in spite of difficulties obtaining filmmaking sup-

plies and services during wartime, he succeeded with a group of friends in making a full-length film of Laurence Sterne's *A Sentimental Journey through France and Italy*. Upon completion of his degree he joined the staff of a London film company.

In 1942, he had staged a production of Marlowe's *Dr. Faustus* for a small theatre in London. After graduation he directed several productions for small theatres, leading to an association (1945) with The Birmingham Repertory Theatre. In 1946, he directed Shakespeare's *Love's Labour's Lost,* designed in the style of Watteau, at the Shakespeare Memorial Theatre, Stratford-upon-Avon. He was the youngest director in the history of the Stratford-upon-Avon Festival.

For the Royal Shakespeare Company (Stratford-upon-Avon), Brook directed, among other productions, *Titus Andronicus* (1955), with Laurence Olivier and Vivien Leigh, *The Tempest* (1957), with John Gielgud, and *King Lear* (1962), with Paul Scofield.

In addition to his productions of Shakespeare, Brook directed the works of other playwrights, including Arthur Miller's *Death of a Salesman* (1951) in Brussels, Tennessee Williams's *Cat on a Hot Tin Roof* (1956) in Paris, and Dürrenmatt's *The Visit* in both New York (1958) and London (1960). He directed productions in musical theatre: *House of Flowers* (1954), with book by Truman Capote and music by Harold Arlen, in New York, *Irma La Douce* in London (1959) and New York (1960).

He also adapted and directed *King Lear* for American television (1953), and directed a cast of children in the first film version of William Golding's novel *Lord of the Flies* (1963).

In 1964, Brook directed Peter Weiss's *The Persecution of Jean-Paul Marat as Performed by the Inmates of the Asylum of Charenton under the Direction of the Marquis de Sade,* in England. The production was brought to the United States in 1965, and won a Tony Award. Set in a lunatic asylum, it has become a hallmark of Brook's theatrical innovation.

In 1970, he thrilled audiences with a production of *A Midsummer Night's Dream* which employed circus techniques. Set in a white box, it has been variously described as taking place in a gym, a squash court, and a tent.

Also in 1970, Brook moved to France and, with Micheline Rozan, founded the International Centre of Theatre Research. In 1974, they reopened the Bouffes du Nord, a dilapidated nineteenth-century theatre in a working-class neighborhood of Paris. From this base of operations, Brook has embarked on a journey of exploration, rediscovering classic texts and experimenting with new theatrical techniques around the world. Brook has assembled an international acting company which, among other projects, has traveled to Africa for experimental performances, created a new language of sound for performances of the *Orghast* in the ruins of Iran's Persepolis, and studied Persian bird myths and anthropological writings for *Conference of the Birds*.

In 1985, Brook produced *The Mahabharata,* an Indian epic that is the longest single poem in world literature. A compilation of myths, folklore, history, and theology, it includes the sacred book of Hindu philosophy. This nine-hour production toured Europe before opening in 1987 at the Brooklyn Academy of Music. In 1993, he developed *L'Homme Qui,* based on actual neurological case studies recorded by Oliver Sacks in *The Man Who Mistook His Wife for a Hat.* Brook's most recent production at the Bouffes du Nord, *Je suis une phénomène,* opened in Paris in April 1998; in July 1998, he returned to opera, staging Mozart's *Don Giovanni,* at Aix-en-Provence.

Brook has written numerous articles and several books, including *The Empty Space* (1968), *The Shifting Point* (1987), and *The Open Door* (1993). His autobiography, *Threads of Time: Recollections,* was published in 1998.

He has received two Tony Awards, an Obie Award, an ACE Award, two Emmy Awards, a New York Drama Critics Circle

Award, and three Grands Prix Dominique. He recently was awarded the 1997 Japanese Praemium Imperiale, presented for outstanding lifetime achievement in arts not recognized by the Nobel Prizes, and he has been named a Chevalier de la Légion d'Honneur by the President of France, and Commander of The British Empire by Queen Elizabeth II.

THE MEADOWS AWARD

The Algur H. Meadows Award for Excellence in the Arts was established in 1978. Its aim is to recognize the highest level of international achievement in the creative and performing arts.

The Award is designed not only to honor the artistic accomplishments of an individual artist, but to provide a forum for the artist to share ideas and aspirations with the students of Southern Methodist University, and is intended to symbolize a continuity of artistic heritage and inspiration from one generation to the next.

The Award, presently fifty thousand dollars, is made possible by the income from a one million dollar endowment grant made to Southern Methodist University by The Meadows Foundation of Dallas. It serves as a permanent memorial to Algur H. Meadows, arts patron and benefactor of The Meadows School of the Arts.

Recipients of The Algur H. Meadows Award for Excellence in the Arts include:

Ingmar Bergman

Martha Graham

John Houseman

Mstislav Rostropovich

Merce Cunningham

Robert Rauschenberg

Arthur Miller

Leontyne Price

Peter Brook

Stephen Sondheim

Paul Taylor

Jacob Lawrence

Winton Marsalis

Angela Lansbury

Acknowledgments

This project has been very close to my heart; my indebtedness to those who have supported it is great.

Above all else is my debt to Kathryn Lang, for courtesy, patience, and, most of all, for uncompromising editorial commitment to quality. My thanks also to Keith Gregory, whose warm reception of the original idea encouraged me to pursue the project, and to Freddie Goff for her generous assistance.

To Peter Brook, without whose permission the project could not have gone forward; to my friend Claire Henze, whose passion and courage were profound lessons; to The Meadows Foundation, for their unique vision of the importance of art in our lives, deepest thanks.

I offer gratitude also to Stephanie Walsh, who realized the initial transcription with patience, humor, and integrity; to Carole Brandt, who provided tangible support; and to Ronnie Day, whose assistance with the tapes allowed the work to begin.

An initial draft was reviewed by colleagues William Eckart, Larry Weirather, and Ralph Leary. A later draft was reviewed and recommended to Southern Methodist University Press by Albert Bermel, John Russell Brown, and Andrew B. Harris. My thanks to them all.

Appreciation to Pam Wendland and Larry Lehman for logistical aid, and to Marsha Holland (Fondren Library), Sylvia Morris (Shakespeare Birthplace Trust), and Michele Mrazik (Trexler Library) for gracious reference support.

I offer special gratitude to Nina Soufy, Assistant to Peter Brook, for her unfailing courtesy and crucial assistance; to Greg Boyd, warm thanks for sharing my passion for Peter Brook's unique artistry.

To those interested in unusually detailed information about specific Brook productions, as well as the overall movement of Brook's career from 1946 to 1993, I note *Peter Brook,* by Albert Hunt and Geoffrey Reeves (Cambridge University Press, 1995).

Finally, to those of my students whose interest, inquiry, and support kept the furnaces of my own commitment stoked for the five years it took to bring this project to completion, my deepest and warmest thanks.

DALE MOFFITT

Index

Photo by: Gershon G. Udel

DALE MOFFITT acted professionally for eight years and has served as head of three undergraduate actor training programs. He holds an A.B. degree in theatre from the University of California at Berkeley, an M.A. from San Francisco State University, and a Ph.D. from Washington State University, with additional study at the Spolin Theatre Games Center, the Royal Academy of Dramatic Art (London), and the Strasberg Theatre Institute, among others. He was named a Meadows Foundation Distinguished Teaching Professor in 1991.

———————

GREGORY BOYD has been Artistic Director of the Alley Theatre, Houston, since 1989. Mr. Boyd also has served as a panelist for the National Endowment for the Arts, the Massachusetts Council for the Arts, and the Texas Commission on the Arts, and has taught on the faculties of Carnegie Mellon, Williams College, and the University of North Carolina, where he headed the Professional Theatre Training Program.